INSIDE THE L.A. ARTIST

Inside the L.A. Artist

Marva Marrow

INTRODUCTION BY
Josine Ianco-Starrels

GIBBS M. SMITH, INC.
PEREGRINE SMITH BOOKS
SALT LAKE CITY

First edition

92 91 90 89 88 3 2 1

Published by Gibbs M. Smith, Inc.,
P.O. Box 667, Layton, Utah 84041.
This is a Peregrine Smith Book

Design by Smith and Clarkson

Cover photograph: Billy Al Bengston
by Marva Marrow

Printed and bound in Hong Kong

**Library of Congress
Cataloging-in-Publication
Data**

Marrow, Marva.
 Inside the L.A. artist.

 1. Artists — California — Los
Angeles — Portraits. 2. Art,
American — California — Los
Angeles. 3. Art, Modern — 20th
century — California — Los Angeles.
I. Title. II. Title: Inside the LA artist.
N6535.L6M37 1988 709'.2'2 87-32894
ISBN 0-87905-297-X

THANK YOU

I must admit that when I started this project, I didn't know what I was getting into. During the 1984 Olympics here in Los Angeles, I was host and photographer to several prominent Italian journalists who had been sent to cover the events and the surroundings. My Italian connection was and is a tight one—I lived there for over eleven wonderful years and actually, at the time of the Olympics, was still officially in residence in Milan. However the call of my American roots was gradually weaning me away, and shortly afterwards, I made the big move.

When these same journalists returned to Italy, I received similar requests from all of them—obviously impressed by the magnificence of the Los Angeles Olympic Arts Festival and the street murals painted for the occasion—for an editorial series on artists of Los Angeles. Thus began a magical time for me, a time that changed my outlook on myself, made me wonderful friends, and definitely deepened my approach to my photography.

The original premise was just to photograph a few artists in a journalistic sort of way. But this soon evolved into a major undertaking, as I became immersed in my subjects and their creations. I came to realize that an artist's work is the most important statement and exten-sion of his/her personality, and I wanted to show that visually to people who might not even be really attracted to art per se. The face behind the work has always been fascinating to me, and, loving people as I do, I found myself in a wonderland of collabora-tion with some of the most inventive and original personalities any-one could hope to meet.

It was most difficult to set a cutoff point for this book, which for reasons of space and time was neces-sary. Let me say that I was interested in present-ing a real cross section of art in L.A., with represen-tatives from all "groups" and non-groups present—famous and non, emerging and submerging, Venice vs. Downtown, male and female.

There are many other valid and valuable artists I would love to have included, and sincere apology is definitely due to all of those.

What I really need to do at this point is thank a (large) number of people who have helped to make this book possible.

First of all, I must thank Josine Ianco-Starrels for believing in me, for giving me of her time, knowledge, encouragement —not to mention all those addresses and names! I was very thrilled to have her write the introductory commentary for this book. She is very much loved in the Los Angeles art com-munity, and has earned the affectionate title of "Art Mother" for her nurturing of budding talent.

My list could really be quite endless, so I will try to be brief and hope that the people I mention real-ize that words can't really convey enough. One more mention: the artists who have participated in *Inside the L.A. Artist*— I love you and am forever grateful.

A & I Color Lab
Gil Aronow
Artform Color Lab
Patrick Aumont
Jim Bonelli
Patrick Djivas
Gamma Liaison Agency
Elaine Gilboa
Henry W. Holmes, Jr.
Selma Holo
Frank Katsumata
Christopher Knight
Friends at L.A.C.C.
Helen Marrow
Hyla Marrow
Keith Nelson
Mario Nicolao
Photo Impact
Nigey and Lionel Rolfe
Susan Roseman
Paul Schimmel
Meryl Schipper
Shooting Star Photo
 Agency
Catherine Smith
Tim Stevens
Kevin Thomas
Olivier Vidal
Adrienne Wagner
Eleanor Wells
Sylvia White

and of course, my husband
. . . Michael Eschger

Marva Marrow

CONTENTS

9 Introduction
 Artists
13 Larry Albright
14 Lita Albuquerque
15 Peter Alexander
16 Martha Alf
17 Carlos Almaraz
18 David Amico
19 Martin Archer
20 Charles Arnoldi
21 Don Bachardy
22 John Baldessari
23 Larry Bell
24 Billy Al Bengston
25 Tony Berlant
26 Roger Boggs
27 William Brice
28 David Bungay
29 Hans Burkhardt
30 Richard Campbell
31 Karen Carson
32 Mary Corse
33 Dennis Curtis
34 Melvin Detroit
35 Richard Diebenkorn
36 Guy Dill
37 Laddie John Dill
38 James Doolin
39 Tomata Du Plenty
40 Claire Falkenstein

41 Sam Francis
42 Curt Friedrichs
43 Mark Gash
44 Candice Gawne
45 Jill Giegerich
46 Gronk
47 Steve Grossman
48 D. J. Hall
49 Lloyd Hamrol
50 Madden Harkness
51 James Hayward
52 Roger Herman
53 George Herms
54 Peter Hess
55 David Hockney
56 Patrick Hogan
57 Robert Irwin
58 Jim Isermann
59 Connie Jenkins
60 Tom Jenkins
61 Mike Kelley
62 Harry Kipper
63 Randall Lavendar
64 Mark Lere
65 Helen Lundeberg
66 Constance Mallinson
67 John McCracken
68 Michael McMillen
69 Jim Morphesis
70 Ed Moses

71 Gwynne Murrill
72 Gifford Myers
73 Victoria Nodiff
74 Baile Oaks
75 Eric Orr
76 Ann Page
77 Laurie Pincus
78 Jack Reilly
79 Roland Reiss
80 Leo Robinson
81 Frank Romero
82 Sandra Mendelsohn
 Rubin
83 Edward Ruscha
84 Betye Saar
85 Peter Shelton
86 Alexis Smith
87 Masami Teraoka
88 Joyce Treiman
89 James Turrell
90 De Wain Valentine
91 Jeffrey Vallance
92 Ruth Weisberg
93 John White
94 Mary Woronow
95 Tom Wudl

97 Selected Biographies

INTRODUCTION

Why do we want to see the faces of the people who make art?

Are we trying to find answers to questions we haven't articulated to ourselves? Is our notion of the artist still imbued with 19th-century Romanticism, or could it be that we are products of our time, conditioned by the media to seek out celebrities and thereby share their fame? After all, a few artists have attained "star" status even if the majority still live anonymous lives, pursuing their goals quietly—working in solitude.

I suggest that our curiosity might be intrigued by their way of life—by the fact that they manage to evade much of the societal programming which prescribes our daily lives. Perhaps we want to understand the artist's willingness to forego the material rewards bestowed on those who relinquish control of their time and energies in exchange for money. I believe that a mixture of fascination and irritation accompanies our wonderment, as we realize that there are human beings who swim against the current and get away with it.

So what makes them able to do what they do? What is the secret which gives them the tenacity to gamble with life, to indulge in the luxury of listening to their own inner voices? Are they different from the rest of us?

Each generation, in every part of the world, in every time, has had its artists. In many cultures the artist was part and parcel of the fabric of society, his talents put to use in the service of the gods, the kings, the popes, the rich and powerful. However, during the 19th century, artists began to lose their place in the increasingly materialistic Western culture. In our time, as materialism has become a worldwide religion, the artist has been exiled, most of his functions replaced by technology, to become an isolated loner, primarily engaged in a monologue with non-functional, self-defined visual research.

While such solitary pursuits rarely allow him/her to earn a living making art, they do provide freedom of thought and access to sensory perceptions which most others have been conditioned to disregard. And, artists continue to emerge in every generation.

So far as I know, no one has been able to define the genetic combination or the environmental factors which produce an artist. Antoine de Saint Exupery tells us that "what is essential is invisible to the eye and has no explanation." Maybe it's just as well that we leave it at that and remain grateful that there are still some mysteries we have not been able to unravel.

What is quite obvious, however, is that a relationship does exist between the artist's personal history and the milieu in which his work is created. Most artists throughout history have distilled their experiences and expressed a vision tempered by the social, political, religious, and geographic conditions of their environment. It is from their images that we pick up clues which allow us to imagine life in the Middle Ages, the Renaissance, 18th-century France, the great civilizations of China and Japan, or any of the tribal societies.

To begin to get "inside" an L.A. artist, is to appreciate the influences of his immediate environment. Within the overall picture of 20th-century America, the West Coast has a unique character. Robust and lusty, it fairly bursts with the vitality needed to chase prosperity. Its self-confident, even cocky strides have little patience with sensitive transitions and fragile souls. The devil does not appear sporadically here. He lives up on the hill and drives a Rolls. The Zen Center is downtown, and in between are umpteen possibilities. . . . It is in this context of opposites that we exist, daily confronting the alternatives of a sybaritic *dolce far niente* existence side by side with the call for spiritual life, while nearby the expensive *dolce vita* provides the incentive to hustle. Rewards depend

9

on the choices we make.

And yet, even here we encounter those who engage in dialogue with the self and search for an inner voice—a voice one would think would be drowned by jackhammers, freeways and jet engines. Just as past aggressive empires spawned their poets and painters, so we witness the tenacious survival of those who "soothe the savage breast," cultivate the garden, and tend to the spirit.

The choice is distraction versus concentration. To be an artist is, by its very nature, a solitary activity. However, the economics of this calling often demand that one work at some other job which keeps bread on the table and pays for materials. Quick exit to *dolce far niente* and *la dolce vita*. Anyone who is a serious artist has to have excess energy, devotion, or commitment to make art here. One must pay the piper for the privilege of marching to his own drummer, and survival has a rather high price tag. Contrary to legend, the artist has to be willing to work twice as hard as any normal citizen—the only motivation being that it is a labor of love. Those who manage to overcome temptation and persevere in this fine madness are the ones whose faces and works you will be seeing on these pages.

Marva's photographs do not invite you to compare art with other art. Instead, she clarifies for us the relationship between the work and the artist, its source, by obliquely alluding to that connection, that mysterious link, between the art and the human being whose spirit inhabits it.

Josine Ianco-Starrels
Los Angeles, California

EXPLANATION OF ARTISTS' TEXT

The artists' statements were written in response to a letter I sent to each one, giving them a choice of answering one of five questions. The questions were to be considered as a guideline, and they were to answer in the manner each felt most appropriate. What I was looking for was an emotional approach to their art . . . something to make "the face behind the work" a little clearer.

The questions were:

1 Where does your work come from?

2 Why do you paint draw or sculpt?

3 What was the moment you knew you had to be an artist?

4 How does your work comment on the world or on yourself?

5 What would you like to say about how you FEEL about your own work?

LARRY ALBRIGHT

What artists say about their work often does more to obscure their art than to clarify it. With this in mind I am going to be brief and, hopefully, to the point. I work out of my personal values and a genuine love for the early days of science when there was an honesty and pure wonder about the way things worked. Objects were built as demonstration apparatus for the marvels of nature, with care being taken in the building of the objects which seemed like marvelous sculptures in themselves. Rosewood and oak turned on lathes to make finials and trim combined with knurled brass knobs, created objects that thrilled me as a youth; and now I collect some examples of these things as chance allows.

In the sculptures I build, the best qualities of old electrical machines are reflected in the use of a few old meters, a touch or two of antique hardware combined with new materials of the same integrity, sometimes a gas discharge globe or an intricate piece of glassware filled with rare gases to provide some form of "magic" with is always present.

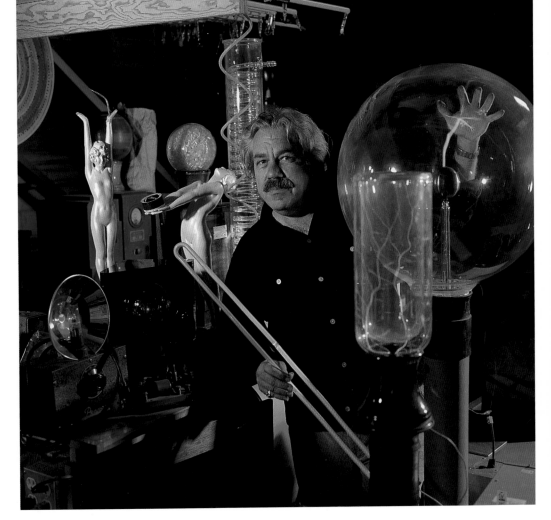

LITA ALBUQUERQUE

Poem from a dream

I know that if I don't do it
don't let the breath in me
spew out the inspirations
from the wind
I will die
my breath will be taken
away from my spirit
and a spear born of loss
will rupture my heart
action of grief and of
intolerance at the denial
of the desire to breathe
into the night
to make a sound in the
night
like wind spiraling down
on earth
spiraling into the spiral of
the cochlea of the inner
ear
of the humans lying there
below sleeping
sleeping/dreaming
dreaming visions from the
wind

Out there
out there in that space we
call universe
out there on the
stratosphere
is the obvious
the torrent of words that
exists
as clearly as the
hieroglyphics of Egypt
stand in the desert. . . .

I know that I must
I know that I must
approach the wall of
words
with my fingers
like a blindwoman
approaches her braille
fingers caressing
ears forward
receiving the spiraling
wind
that guides the fingers to
the meaning

I must move toward the
braille of my destiny
for in the shadow of that
braille
lies the vision that exists
without eyes.

In The Shadows
The Ancients string beads
on the Abacus of Time
Each bead, a microcosm of
a year of a life in universe.

The Ancients took me into

their circle for an instant
and let me see it
the Abacus, guardian of
time
I was struck by one bead
among them
as I got closer I noticed it
was a pearl
a reflective pearl
transparent, lucid, brilliant
in it reflectivity among
time

They held it up for me
and said,
"This is your planet, we
call it the blue planet,"
then they whispered, "We
hope you know it is
a pearl and are taking care
of it as such," as they
receded
in the shadow.

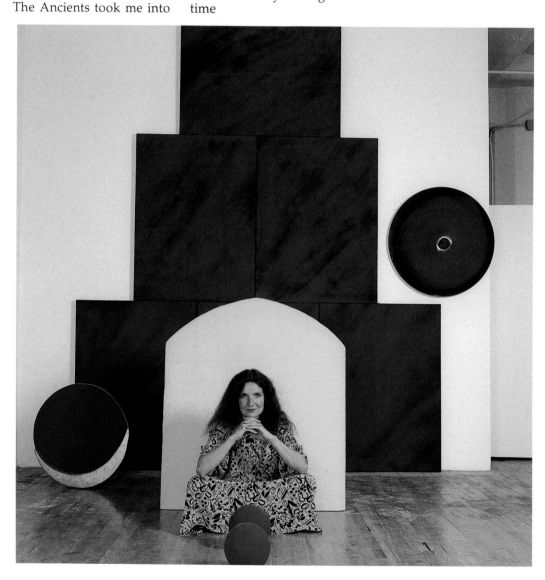

PETER ALEXANDER

*What was the moment you
knew you had to be an artist?*

1½ years

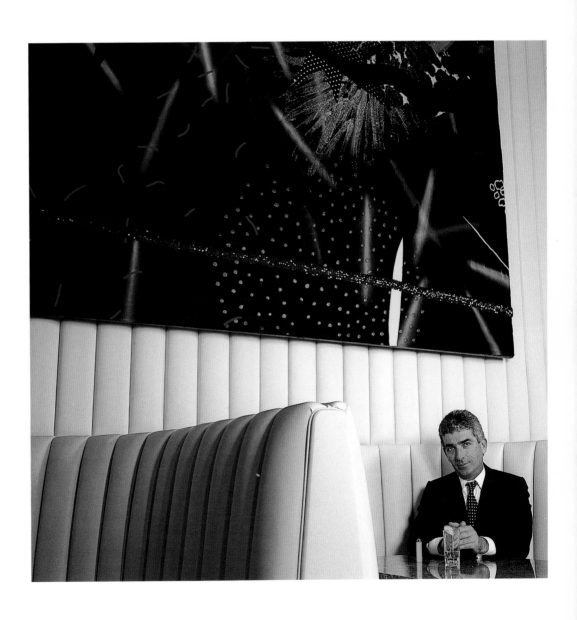

MARTHA ALF

I enjoy the surprise of transforming the materials of painting and drawing into a new visual experience that didn't exist before. What is now a totally personal experience comes from many years of study of the art of others and discovering that what attracted me to them was really part of myself. Through years of obsessive, often repetitive art making, I achieved a mastery of materials and means so that the visible result is now a direct extension of my mental and psychological inner self into new images accessible to others.

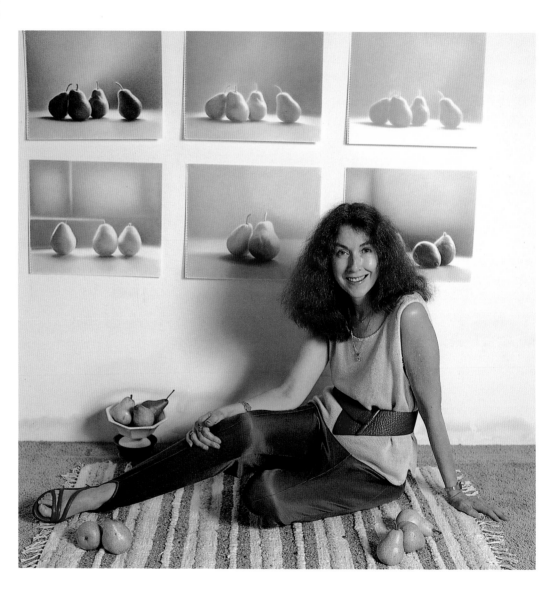

CARLOS ALMARAZ

I feel that my paintings and before that, my drawings, are like an open journal to my life and to my intellectual preoccupations. As life changes so does the content of my work. And, as the world changes, and it does change, so does my perception of it. We must never be afraid of change because so often it means growth; and isn't that the whole reason for living?

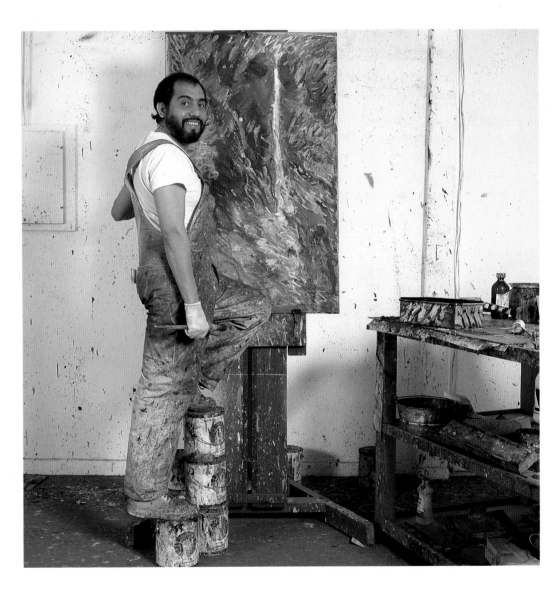

DAVID AMICO

To experience the joy of the human mind, to question . . .

Communication to someone other than oneself is a constant.

The hope of a satisfying existence for all . . .

My experience is common to the experience of all artists.

My art is an attempt to contribute to others.

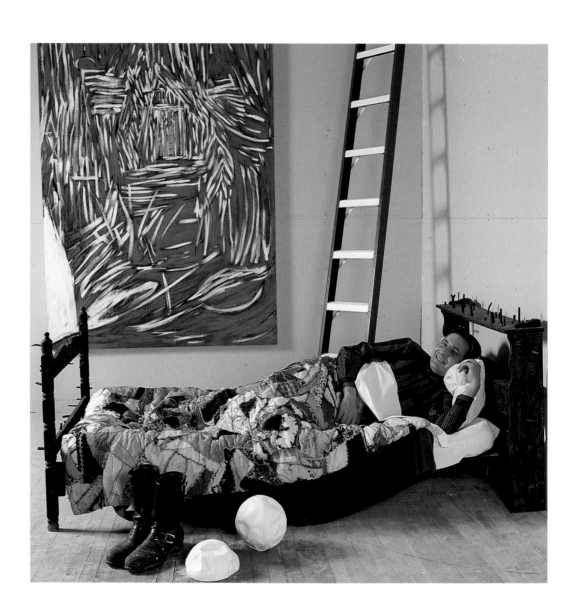

MARTIN ARCHER

Most of my drawings come to me through my dreams which are clearly colorful and metaphorical. Nearly every morning I remember a disturbingly detailed and thorough account—vivid surreal landscapes and tonal pictures, sometimes amusing and amazing, sometimes tinged with a sort of comic book terror. I have actually seem myself in dreams drawing an illustration and then, when I wake up, I try to execute it. Although nothing I have drawn comes near the wild intensity or quiet lull of my Sleep World, it's clear to me that is where a lot of my art originates.

I think my illustrations tend to be on the "light side," humorous and fantastical, but some people find my work disturbing or perplexing. Outside of work-related assignments, everything I do is to amuse myself, nothing more.

Some drawings do not materialize until certain elements (or fundamentals) appear to me. I have to wait until they are ready to be drawn. By now, I've accepted my role in conjuring these visual voices. When I was younger I would silence them with a certain psychic stubbornness I mistook as control. But if my work has become more refined, detailed and polished in the past few years, it is because I have accepted that these images are being released from magic bonds holding them/me back, and as they are gradually revealed to me, I do find myself in a more precise and beautiful Arena.

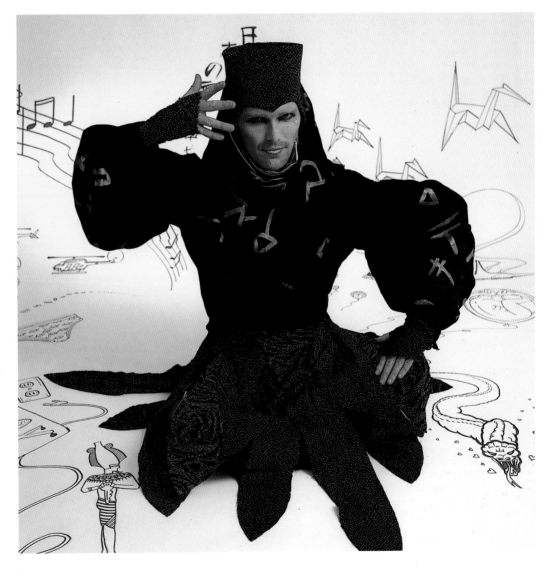

CHARLES ARNOLDI

I think artists themselves are curious about why they do what they do. In my opinion, being an artist isn't that much different than being a plumber or carpenter or businessman. I don't think anyone seeks to do art because it's a great wonderful supernatural thing. It's what feels comfortable and you get there by some sort of natural instinct.

Making art involves a lot of constant self-questioning and experimenting. The artworks are the results of the experiments.

Art is a record of one human life and its discipline, honesty and exploration. It doesn't need to satisfy a need like hunger or shelter, but seems to be as necessary to existence as any of those basics.

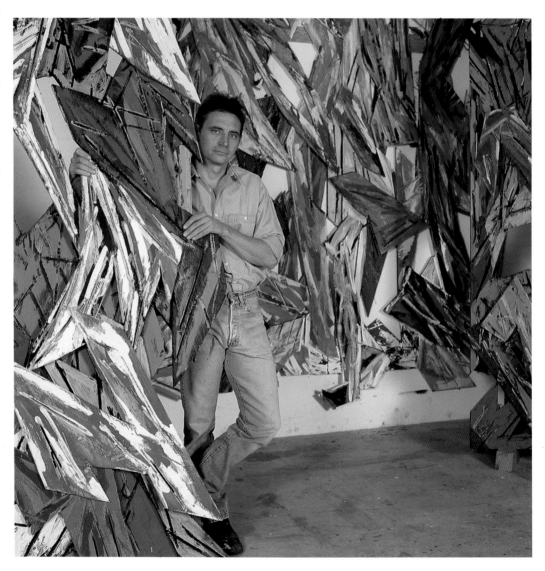

DON BACHARDY

My drawings and paintings are an actual record of what I look at and react to each day, a graphic journal of my daily working experience.

People are my only subjects and I work only from life. Therefore, I schedule sittings almost every day. When my sitter arrives, I go to work. I may do a series of drawings, usually starting in black and white and then going on to color, and may do only two or three or as many as ten or more in a day, depending on the patience and endurance of my sitter. If I am working in color on canvas [usually about four by five feet in size], I can only do one or at most two in an all day session. Everything I do is completed in one sitting. I never work on a drawing or painting except in the presence of my sitter and with the maximum of his or her cooperation and consideration. In that way, my works are a joint effort, a collaboration of artist and sitter. That is why I ask my sitters to sign and date my drawings. I would ask them to sign my paintings as well if not for the difficulties presented by a still-wet canvas and the unfamiliarity of most of my sitters with paint brushes as writing instruments. I have been pursuing this method of work for well over twenty-five years and so have a record of not only what I was doing on a particular day but a facsi-mile of the person with whom I spent that day.

I believe every work of art should communicate a substantial experience in order to justify its existence. The more exciting and intense the experience is while the work is being created, the better the chances are that an exciting drawing or painting will result. If the artist is bored when he creates the work, the work must convey his boredom. It is not my aim to communicate boredom and, far from becoming bored with the repetition of my working routine, I feel an ever-increasing challenge with each new, mysterious and fascinating person I encounter beyond my easel.

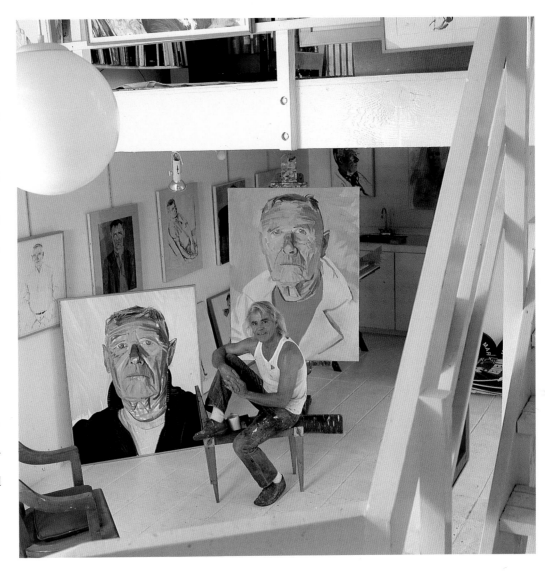

currently derive most of my imagery from movie stills. I intend them as sort of archetypal images that are not connected to any particular period of time. For example, if there is an image of a door, I like it to read as DOOR, not 1920s DOOR or 40s DOOR.

I think my approach is a very difficult one. My idea is not to spell things out in primer book fashion, nor make things so totally opaque that there's no way to get into it, but somewhere in between. I'm sort of relying on a triangulation—the work, the artist and the perceiver. I assume that it's going to be a fairly sophisticated person looking at these pieces.

On the other hand, I try to make the works graded in several levels, in different layers, like an onion. In the first layer there is a certain amount of retinal excitement you get from looking at it, and if you only get that, that's fine. But I would like to provide layers upon layers upon layers so it's as inexhaustible as I can make it. If it's only one-dimensional, I think I've failed.

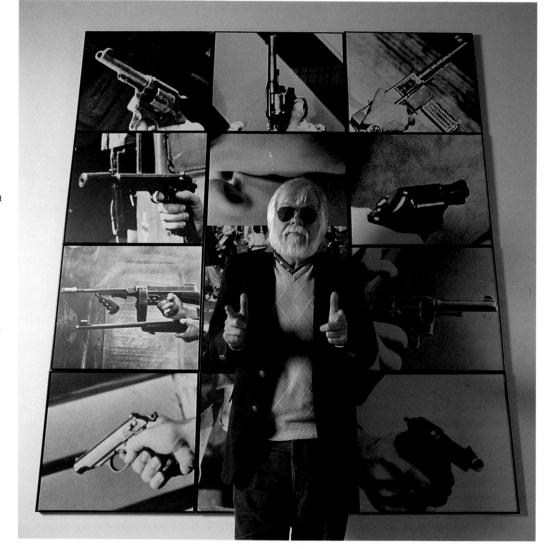

LARRY BELL

I think that the most important thing for the dreamer, for all dreamers, is the example of the people who carry on in face of the general tyranny, doing things that are for other dreamers, whether there is a big audience or not. I know that they're out there, and we need each other. We rely on each other as confederates. I don't know what percentage of the people who come to my studio will be dreamers, but I know that some will come, even if it's half of one percent. Those people will see the work, and they'll understand. They're the audience for me. I hope my work will mean something to the general audience, too, but I'm not going to try to conjure the work to mean something to them, because it can't be done. That's what separates entertainment from art. The entertainment industry can't possibly focus on half of one percent of the general audience.

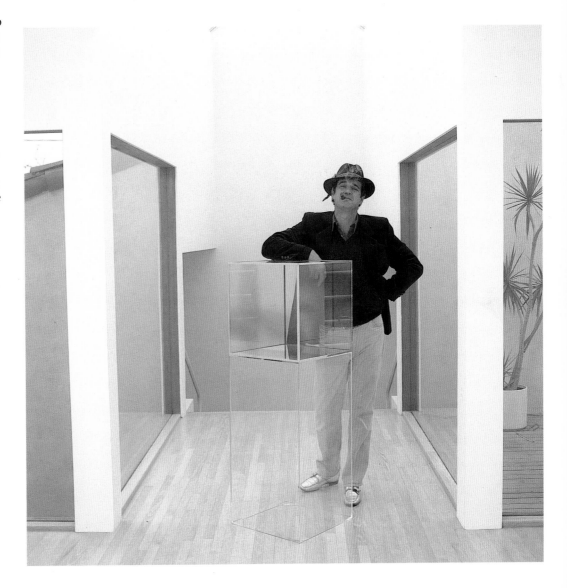

BILLY AL BENGSTON

The most I can tell you about my work is that I stopped talking about it 25 years ago. My work is personal and hopefully people will be able to interpret it that way.

I realized I had to become an artist the moment I knew I couldn't do anything else. I can almost pick out the day. It was summer and I think it was in 1957. Nothing else in my life was happening until then. You know, you always try to kid people when you're a young man, at least in my day. In the 50s, if you ever admitted you were an artist, they'd send you to a psychiatrist and think you were a "faggot." It was definitely a personal rights situation at the time. I didn't know anyone then who called himself an artist. They called themselves painters, sculptors, ceramicists, craftsmen—anything but artists. Now they all call themselves artists and I want to call myself a potter or something! This happened when I was living in Silver Lake near downtown Los Angeles. It was on Alvarado street that I came to this great enlightenment—The Alvarado Enlightenment I was an artist.

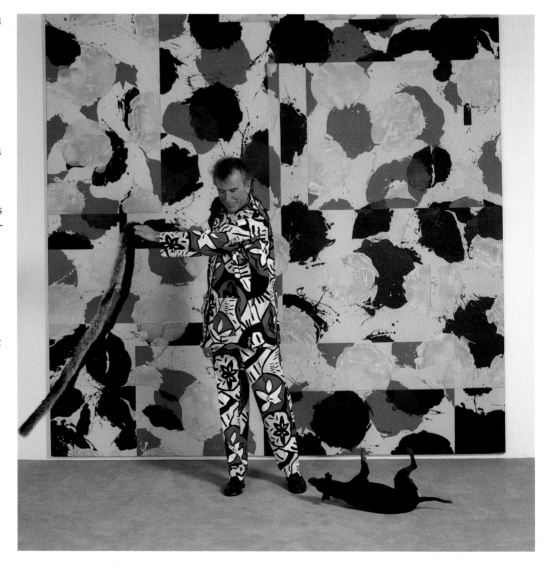

TONY BERLANT

The moment that I first knew I had to be an artist was in 1958, when I was a high school senior. Our class went to the Los Angeles County Museum to see a Van Gogh Exhibition. At this time the Natural History Museum and the Art Museum were all under the same roof. I had always been fascinated by their naturalistic specimens, especially the prehistoric animals, but up until this time I had not been particularly attracted to the Fine Art section of the Museum.

After seeing the Van Gogh show, we were given time to explore the museum on our own and I went upstairs to the contemporary art area where I saw my first Pollock, Still and Rothko paintings, and most particularly, the Picasso "Woman With A Green Handkerchief." A big bell went off in my head which hasn't stopped ringing.

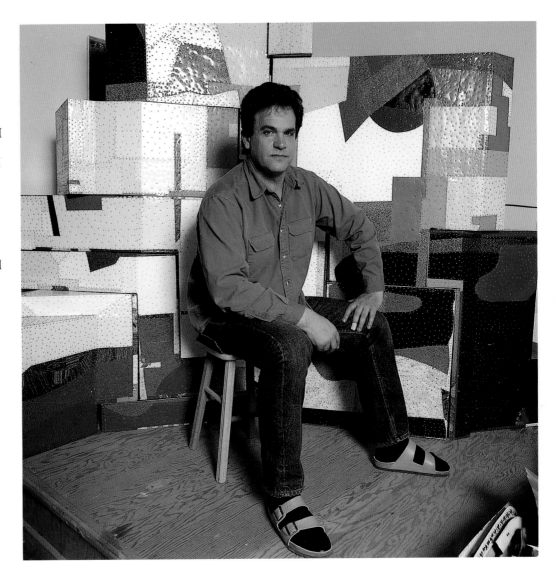

ROGER BOGGS

My work comes from everything around me. It comes from what I see other artists doing, from what I see other people doing on the streets, from the influence of our multi-faceted society of social and religious laws, symbols and myths.

I try to interpret these symbols in what I consider to be an artistic manner, keeping in mind artist's symbols, laws and myths, in order to create as little confusion to the viewer as possible.

Any comment I am trying to make on society or the world, I would like to make in an upbeat manner through the use of color, materials and size.

The way I feel about my work is the way it looks.

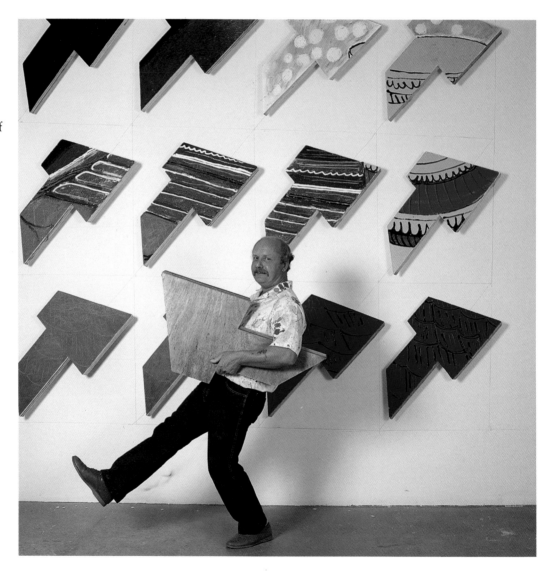

WILLIAM BRICE

I do not recall a time when I did not draw and paint. When I was fourteen I first studied drawing and painting. By the time I was sixteen, I knew I would be an artist.

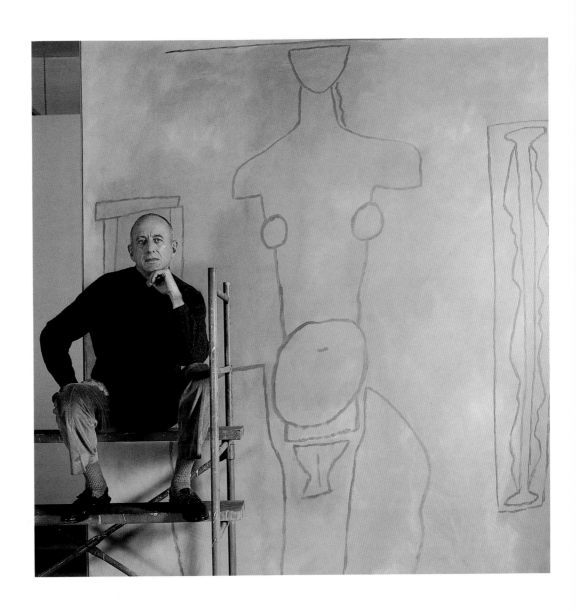

DAVID BUNGAY

What I'd like to achieve in painting is this movement or shift between objective reality and abstraction, so that the work vibrates between these two spaces. For me, painting should do something or it just sits there as decoration or failure. Somewhere I read a statement that remains significant for me: "All forms are allies that indict the arts whose falsity they know."

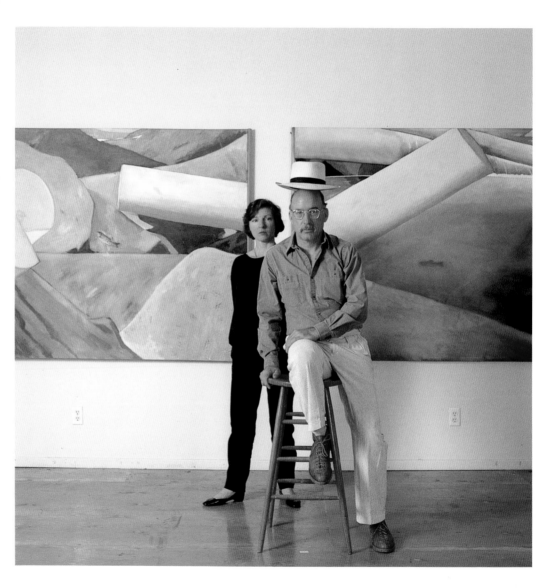

HANS BURKHARDT

My ideas for painting come from nature—the figure, landscapes, tortured nails or rusty wires of a city dump, the happy play as well as the sad faces of children, the seeds of a tree falling on the grave of an unknown, and social and political upheaval.

Because God created nature so beautiful, why should I copy it? I cannot copy it and make it any better, so I make it my own. Look how the world has changed in fifty years. You can't do one painting and make the same thing over and over.

I feel whenever I accomplish something, I have to be satisfied, even if it doesn't please anyone else.

I paint the way I live.

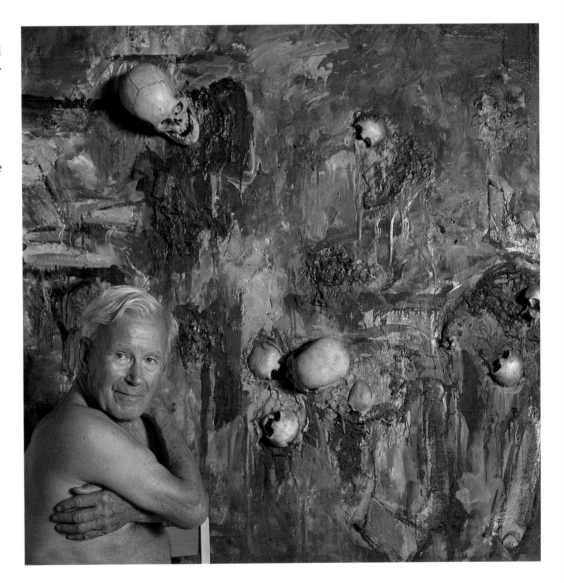

RICHARD CAMPBELL

My early work was socio-political in nature. The figures I painted reflected my somewhat dark view of the world. These works included prints and oils which were done with flat brush strokes in deep and somber colors.

The work I've been doing in the eighties is the result of a transformational journey I've experienced. I guess you could say I have tapped into unexplored areas of my unconscious. The shapes and images I now paint come in dreams and meditations. I love color. Bright explosions of color. I feel that my new path is a gift, a new language opened to me after a serious illness. The ever-present joy of life I feel provides me with a constant flow of inspiration.

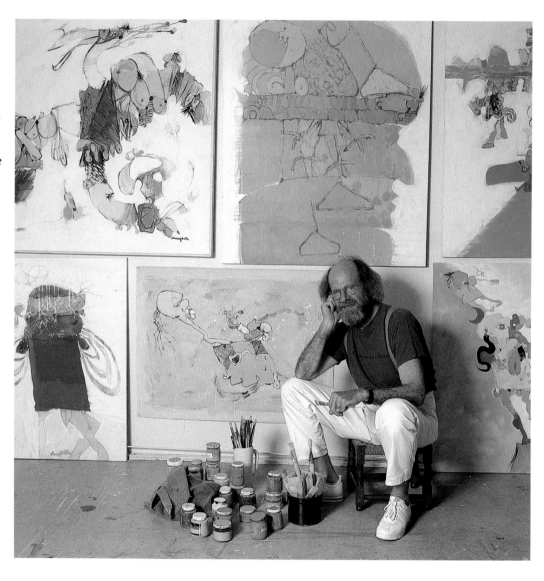

KAREN CARSON

I have made art since I was a child because I wanted to know things and make objects that otherwise were not available to me.

I made a fantasy world for myself like many children do, but I did not have invisible friends, play with dolls, or many other imaginary games. I drew constantly and it seemed to make me entirely comfortable with my world.

My art still provides me with that fantasy stimulation. It's still my chance to be out-of-this-world and with myself. I do understand and respect my connection to other artists and to art through time. I also make images from my understanding of my surroundings and time. But at its core my reasons for making my art are highly personal and deeply felt.

I love painting and drawing because it is such a peculiar act— that of visually manipulating tangible things, making them into odd, flat, illusionist, patterned, and strangely ordered images on paper or canvas. It is endlessly intriguing and revealing.

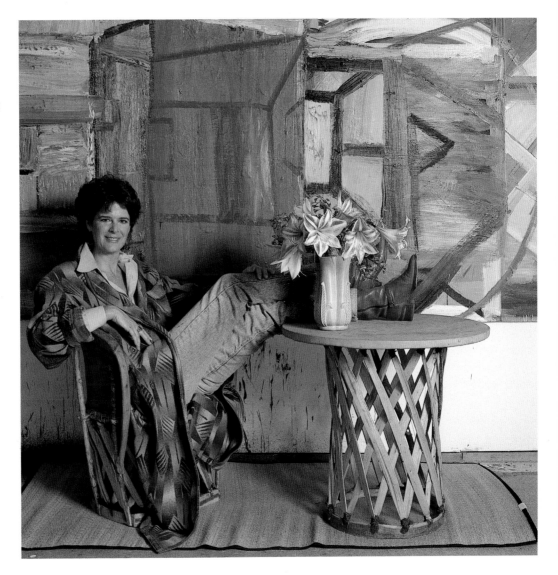

MARY CORSE

Early on I was dissatisfied with painting being of a static image or being of paint on the surface. For me the concept of painting, what painting is and the world it could create for you, was important. Nothing in nature or life is static; it made sense that the brush strokes and images on a canvas should change also.

The white light paintings incorporate micro glass spheres which prism the light in relation to the viewer. As the viewer moves, the painting subtly changes. Also, when I put the prisms in the paint I was really putting the light inside the painting. The rainbow and light changes are in the surface. I wanted to go beyond the surface.

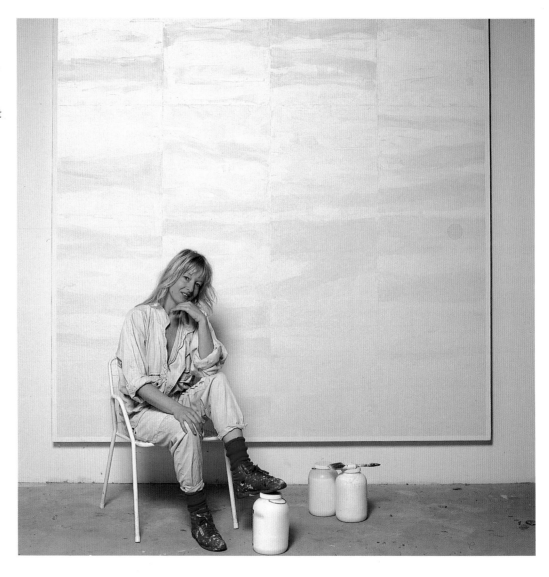

DENNIS CURTIS

I make art, or try to, because I need to. Very few goals or things give me as much pleasure as does this perennial mystery of making something from nothing.

Life for me would have been over a dozen different ways a long time ago had it not been for what the aesthetic plane has given back to me. There is nothing else I would rather do. It is a perfect substitute for not being born rich.

Art gives me good reasons for being outside the mainstream; an observer, a stranger, an outlaw even. Following this particular muse has given me the freedom that I don't believe I could have in any other field.

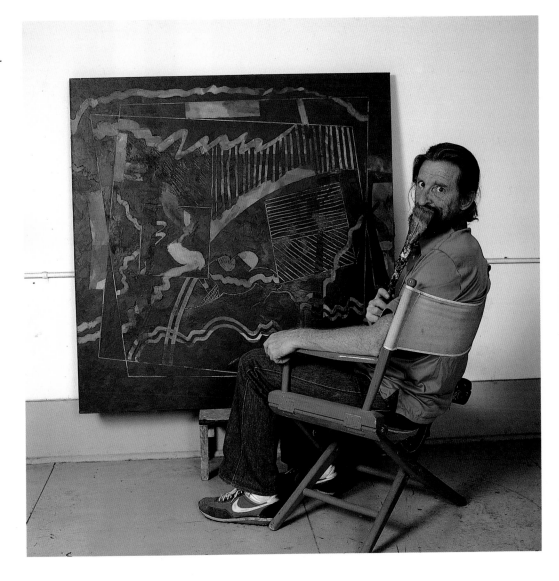

MELVIN DETROIT

A man lived inside a shape. The shape was architecture, simple, a house. The shape protected him from the vagaries of environment. He imagined his shape as a philosopher's tower, he questioned the world. He used his intellect and imagination to search for truth in his ideas. To his thought he added color and form. Eventually he made pictures. He joined the society of the imagination and knew his work as a privilege and a responsibility. He coaxed others into his realm to exchange realities. Through him, others would travel into speculative worlds just as he did when he created. He was satisfied with his involvement, his mind moving forward in an unpredictable landscape pliable to the artist's touch.

RICHARD DIEBENKORN

Note: *Richard Diebenkorn*
is a very public figure
as an artist, but very
private as a person.
He preferred not to make
any verbal statement. —M.M.

GUY DILL

The art requires that I allow information and influence in from the beginning of history forward.

It is socially responsive art because it is done now—a criss-cross of geography, culture and time.

LADDIE JOHN DILL

I think my own personal methodology perhaps started around 1970, and since then it's been an evolutionary process of one piece leading me to the next—the previous piece lending enough information to go on to make the next piece. I progress relatively slowly, and I don't jump into another radical form or anything like that; but if you look at the work over a period of years, you can see the progression from working with pure light sources and natural materials in their natural state, like sand, up to relatively geometric architecturally-based forms dealing with cement and plate glass.

The technical aspect of my work is uniquely mine. Some artists are able to manipulate gouache or oil paint or work with video or dance. My interests lie in the use of systems of materials.

Sometimes I'll be explaining my work, and I'll lapse into these long technical dissertations. I don't think of it that way, but people come back to me and say, "Your work is so technical." But it isn't to me. My father was a lens designer, a scientist. He helped me with some of my early work when I was a teen-ager. The idea of analysis and a scientific approach comes quite naturally to me, but I like to use it in a creative sense.

I insist on a fairly large studio, because I have one area of the studio where I'm making pieces and another area which is purely experimental. It enables me to separate the ideas of making art and just experimenting with materials and seeing what relationships I can get between myself and the materials and between the materials.

I have a tendency to think things out mentally and never physically make them. That's exciting to me, working out a game plan. I also paint, and I

think the reason I paint is just pure expression—to counterbalance the more scientific side of the work.

I come from a genera-

tion where the idea for a sculpture was completed before the execution. But what I'm trying to do is incorporate expressionistic methodology in relation to that. A classic example would be an early piece that I did with sand and glass. The glass was set up in a very highly complex geometric pattern, simple in its arrangement

but complex in its finality— the way the light went through it. The whole piece was suspended in seven tones of sand that

was arbitrarily spread out, but the sand was very important to the structure of the piece. It actually was the substance that held the piece together. And so as arbitrary as these mounds appeared, they were very integral to the structure of this architectural form.

My present work reflects this approach.

There is a strong geometric feeling and, at the same time, an emotional or expressionistic edge that's introduced.

JAMES DOOLIN

I have always experienced profound pleasure from the act of looking, and am constantly surprised and awed by what I see. I want my pictures to recreate that sense of wonder.

It seems that the main subject in all of my work is light, which is, of course, the medium by which we see.

People often say "I see" when they mean that they understand. And so I think my work is basically about seeing, both in the physical and the understanding sense.

TOMATA DU PLENTY

I could sum up my work in one word: adventure. Adventure as in a journey that has only just begun. I only paint people and animals. As they appear on paper or canvas, I start to feel pangs of excitement in my head. The men, the women, the dogs, the cats, the snakes and insects are dreams come to life. Without question I can say I get a thrill out of them all.

How often have I fallen in love with a face or a hand or a neck I've just drawn?

Countless times. And every living thing that appears before me I've seen before. (But I can't always remember where.) Several times, when I look at a face or at the way a figure stands or leans, I recognize someone I know. More likely some-one I haven't seen for years. My mother, dead now some ten years, seems to get some special kick showing up from time to time in a painting. A girl I saw on the freeway once, a jackass I saw when I was 9 years old at the Grand Canyon, a bully from high school, the fat lady who used to blow up balloons at Pacific Ocean Park— these are the folks that come back. I see it . . . and it's a wonder.

CLAIRE FALKENSTEIN

*How does my work comment
on the world and on myself?*

Look *"inward-outward"* and
reveal the way of *art*. By
looking inward you find
your own way. By looking
outward you are placed in
the continuum of nature
and the unfolding
environment.

How would it be if it
were only *"inward"* or only
"outward?" Out of *"outward"*
comes newness and out of
"inward-outward" together
comes renewal.

SAM FRANCIS

I found that matter
followed

Nature in perfect
obedience.

I found force is docile to
wisdom

which makes eternal
circles.

If properly taken science
confirms

the dazzling conception
that

the universe is in perfect
obedience

to the laws of Nature.

The laws of Nature regu-
late all

rising, falling, spreading,
moving,

winging, loving, blossom-
ing, dying,

living, and are arranged
in Beauty. So science is
the

study of Beauty.

Science could be a
symbolic

mirror for supernatural
truths.

Nothing is lost,
nothing is created.

Our work is sacred activity
instructed by Beauty itself.

Beauty is a raging sea of
fire

out of which the frail
blossom
falls.

The order of the world is
the

beauty of the world and is
invisible.

Beauty bites at my heart.

I am living with my
bones,

they are still red.

This is Radiance.

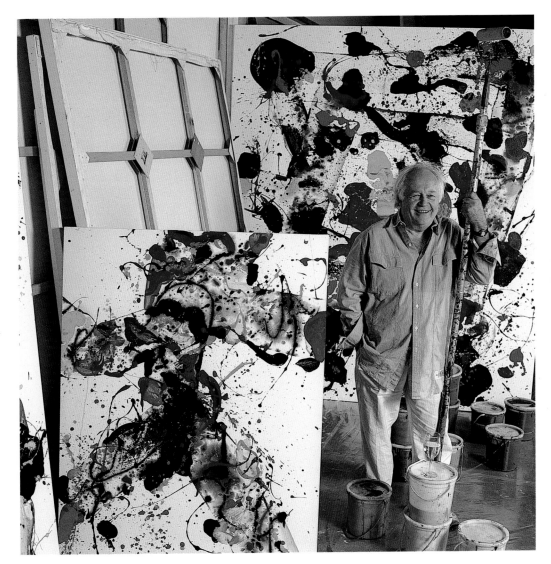

CURT FRIEDRICHS

I have never been totally comfortable with my verbal communication skills, whether trying to put my own thoughts and feelings into some logical order, or just talking to others. Painting, for me, has always been a sort of coded vocabulary that allows me the luxury of expressing these things I have inside, thoughts and feelings, that I would never be able to bring out and verbalize otherwise. All art should work this way if it is an honest statement from the artist. As a result, I'm always learning things about myself through each painting, as each piece becomes an exercise in introspection. The painting in the photograph is called "The Outsider." I guess I'm the outsider. I'm not really comfortable even writing this statement. I feel almost as though I am making a confession, but then again, a good piece of art, in a way, should be a confession.

MARK GASH

When I was a very small child I would bother my mother day and night for different things in and outside of our home. "Mom! I want a drink! Mom! I want this toy! Mom! I want that toy! Mom! I want to go to the store! Mom! I want to go get a hamburger! Mom! I want a" Finally my mother told me to shut up and draw, and I have drawn ever since. Unfortunately for my mother, her solution to my constant pestering only led to my bothering her for something to draw with along with everything else I continued to ask her for. If ever asked what or who led me to art, I always answer . . . my mother and boredom.

CANDICE GAWNE

I live through my eyes. Visions from daily life are points of departure for my paintings. They are the perceptual doorways that hypnotically transport me beyond my mundane view to larger unknown territories of feeling and experience. With sticks I manipulate the thick sensual oil colors to energize the surface and show the shimmering alignment of physical life force and spiritual energy. Time propels me through dark passages of fear toward beckoning bright auras of revelation, reflection and self-discovery, where I strive for balance and grace on the delicate tight-rope of life.

JILL GIEGERICH

The subject matter of my work is quite direct. It involves the things I look at in my daily experience; an image seen or a form that rivets my attention. I can't say exactly what the work means, probably because I'm often trying to work with images that are almost empty, and being close to empty, are ready to be built by anyone who looks at them. I do not intend for my work to have definable metaphorical content. I do intend for it to attract and repel meaning.

What made you become an artist?

the tingler, north by northwest, vertigo, 8½, red desert, invaders from mars, touch of evil, once upon a time in the west, make mine mink, weekend, shame, devil girl from mars, war of the worlds, a place in the sun, sunset blvd., sandstorm, el, the mexican bus ride, pajanga, band of outsiders, last year at marienbad, l'avventura, psycho, pajama game, damn yankees, some like it hot, the palm beach story, the lady eve, the thing 1980, detour, la fête, night and day, a knife in the water, intimate lighting, straw hat, rules of the game, house on haunted hill, the leopard, death in venice, the apartment, the haunting, battle of algiers, umbrellas of cherbourg, cleo from 5-7, my uncle, mathra, nashville, attack of the crab monsters, attack of the 50 foot woman, queen of outer space, the birds, dawn of the dead, titanic, a room to let, fura, it happened one night, metropolis, in the realm of the senses, hitler, some came running, double indemnity, cleopatra 1984, stagecoach, the wedding, goldrush, actas de mar duce, a married woman, king kong, beauty and the beast, bride of frankenstein, thorn of blood, in the year of twelve moons, imitation of life, swamp diamonds, the unearthly, all the movies i've seen, all the bernard herman, nino rota music scores, all the tv shows, man from u.n.c.l.e., green acres, i love lucy, outer limits, twilight zone, december bride, topper, etc., all the books i've read, all the bus rides i've taken, and all the people i've met—all of these things have influenced my work.

STEVE GROSSMAN

To create something truly new in a painting that hasn't been seen before is really the bottom line of what painting is about for me. This same newness of experience, a newness that also exhibits quality and integrity is what excites and engages me when I see it in a painting. Not new for the sake of being new alone, but as a way of providing the viewer with a visual experience that has the ability to surprise, challenge, and ultimately take one's breath away. That's every painter's fantasy I suppose. That illusive something, that great idea is always a factor which often seems as if it's just around the next bend. And when it's not, I just keep searching. The hunt, not the capture—the journey, rather than reaching the final destination—is what really motivates me to keep painting. The small victories point toward new possibilities and shake up old ideas as the cycle repeats itself.

Alone in the studio is never really being alone. The weight and wonder of paintings' previous accomplishments are always there. It's as if all of the great painters of the past are just over my shoulder, sometimes shaking a finger in disapproval, sometimes allowing me a small victory here and there. The history of painting, with all of that quality to live up to, along with the difficulty of the decisions that must be made in the studio to stake out my own territory, provides me with an experience that I find complex, engaging, and sometimes very exciting. It's an experience I find nowhere else. This process by which a painter clears a creative space for himself in the shadow of his predecessors is a necessary and ongoing cycle of renewal. Once the clearing is hacked out of the brush, it must be maintained from the encroachment of the surrounding forest. In this way a base camp is established from which to set out on daily adventures.

D. J. HALL

Initially my work emphasized social commentary on an image-conscious culture in which women are preoccupied with physical appearance, fleeting youth, and aging. Some saw my early work (mid-seventies) as relentlessly unkind but I believe my concentration on every wrinkle and cellulite was my own way of resisting and overcoming society's superficial values imposed upon women and passed on through generations of mother-daughter relationships. In truth, I viewed my subjects with empathy and depicted them with a bittersweet humor inherent in their/our vulnerability.

Often I situated my subjects in or at pools—probably the result of my growing up in Southern California where I observed that leisure time spent in sun-worship was equated with good living. And, in recent years, I've come to realize that my attraction to pool side settings springs from the childhood feelings of joy and security I glimpsed on summer afternoons spent at my grandma's pool.

As pools appear less in my current work, other aspects are achieving greater importance. My subjects are posed closer together in a joyful camaraderie; the handling of flesh is more gentle; flowers are becoming important elements; and birthday cakes crop up occasionally out of an instinctive urge.

I like to think my work is becoming more of a personal commentary— perhaps a reflection of my own journey towards maturity.

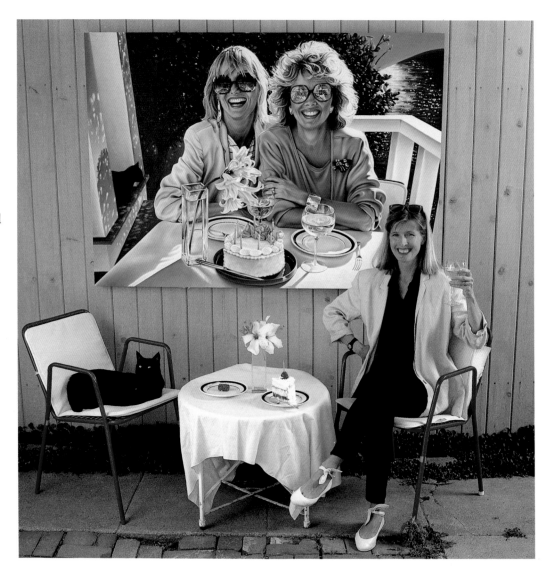

LLOYD HAMROL

Site determined work became vital to me as a result of my participation in a "performance" piece created by Claes Oldenburg for a Los Angeles public space in 1964. The experience was a real shocker. It took some time for me to resolve the contradiction I felt between Oldenburg's "pop" imagery/theatrical improvisation and my own predilection for formal objects and structures.

My increasing appetite for a truly public art led me toward making site pieces which are also arenas for the staged and informal activities of other people. However, in developing "Uptown Rocker," the piece in the photo, I found the restrictive site not conducive to direct public participation. This situation forced me to reconsider the relevance of a large, object sculpture in a public space. Once again, I was reminded of Oldenburg's sensibility, of the importance of humor as a measure of monumentality.

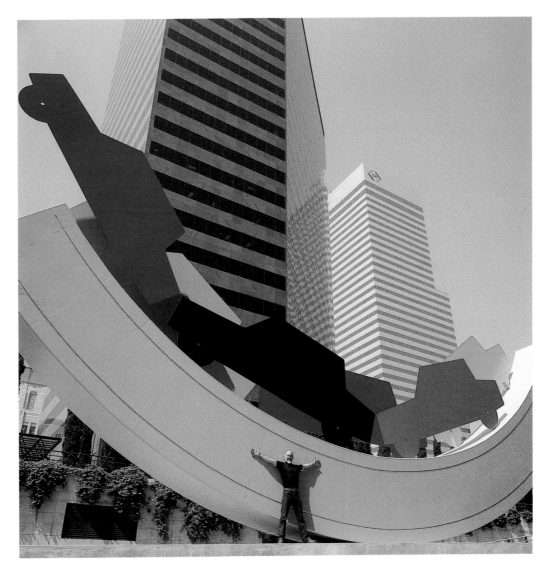

When I was fifteen years old, my family took me to Europe. The first country we traveled in was Italy. I can remember visiting the Galleria Borghese, seeing Bernini's "David" and later seeing Michelangelo's unfinished sculptures. The experience was so powerful that I was never the same person again. After that, my strongest desire was to be an artist. Somehow I understood that this was to be my way of connecting with the world—with life.

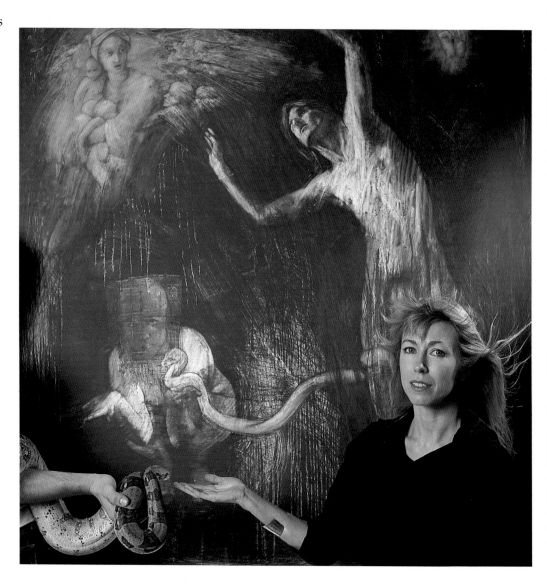

JAMES HAYWARD

Painting is the highest form of art and the lowest form of intellectual pursuit. Abstract painting is the purest form evolved from this noble tradition. Visual form is simultaneously reduced and expanded into ideal form/visual truth. Abstract painting is alien to natural form. The idea/object is, however, quite natural. This concept form is totally human and available to all humanity. These, then, are about seeing . . . beyond reality.

These ideas and their subsequent realities are of great interest to me. Were I wealthy, I would collect. I am not, so I paint masterpieces for myself. I love to look at my own work. I know that must sound terrible, but it is absolutely true. In fact my work quite often leaves me in awe. I look and wonder at how this thing came to be. It is wonderful and impossible, and I am honored to be its origin. It is equally exhausting and nearly impossible to realize. It is easily as demanding as reality and far more elusive. Any asshole can empty a space. It is filling it that eludes most who "show us."

"How do you do that," they ask?"

"How did I do that," I wonder. I now feel totally inadequate at repairing my earlier works. Repairing paintings is the worst job on the planet earth. I would rather burn a painting than repair one.

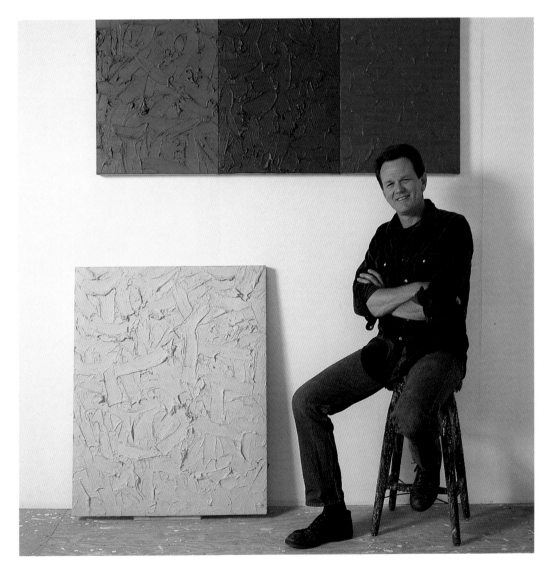

ROGER HERMAN

In the last years my paintings have dealt with the "aura" of images, the "aura" of painting (all cultural assumptions about it). By making pictures with paint that didn't want to be literary or literal but abstract, by repeating images and emptying out the initial content, I entered the arena of the painter with all the problems and critical aspects of the media.

From "historic" paintings I moved to more everyday images, architecture, interiors and exteriors. No social comment is meant by these. They are different possibilities for me to make paintings.

Painting can only survive if it acknowledges its time, if it dresses down, demystifies itself, is critical to its own aura.

The cynic in me is the painter's good friend.

GEORGE HERMS

The work comes from

ineptitude

the mastery sweet

dart boards

and

tossed salads

laughter unthorns

from within

here's looking at you

life.

The family art collection played a great part in my development as an artist. Although they are scarcely a dozen pieces, none of which are distinguished artistically, these oil paintings, sculptures, and etchings comprised the art world for me in my formative years.

I originally regarded our art objects as little more than furniture. The family eventually moved from Holland to America, from apartment to apartment, and from house to house. We discarded many possessions, replacing them with new ones. It soon became evident that, while sofas may come and go, our modest art collection was a permanent feature which would follow us wherever we moved. I learned that these things had some intrinsic worth greater than the value of most of the other things we owned. It was a fact that held true even when you took into consideration their mediocrity. At some point it struck me that the making of such things was a worthwhile endeavor, and my relationship with art was cemented.

DAVID HOCKNEY

At the age of eleven I'd decided, in my mind, that I wanted to be an artist, but the meaning of the word "artist" to me then was very vague—the man who made Christmas cards was an artist, the man who painted posters was an artist, the man who just did lettering for posters was an artist. Anyone was an artist who in his job had to pick up a brush and paint something.

It's difficult to say *why* I decided I wanted to be an artist. Obviously, I had some facility, more than other people, but sometimes facility comes because one is more interested in looking at things, examining them, and making a representation of them, more interested in the visual world, than other people are. When I was eleven, the only art you saw in a town like Bradford, England, was the art of painting posters and signs. This was how one made one's living as an artist, I thought. The idea of an artist just spending his time painting pictures, for himself, didn't really occur to me. Of course I knew there were paintings you saw in books and in galleries, but I thought they were done in the evenings, when the artists had finished painting the signs or Christmas cards or whatever they made their living from.

PATRICK HOGAN

I believe that every artist has some inexplicable need to create. It's probably universal for all painters; there is just a need that demands to be fulfilled. With me, I have that same attraction to paint—I feel obligated to paint; it's a means of making yourself feel a meaningful part of society at large. It is by no means the easiest job, nor the most lucrative. But the knowledge that I'm making something from nothing seems to me to be an almost mystical thing, even though mysticism, per se, is of no real interest to me.

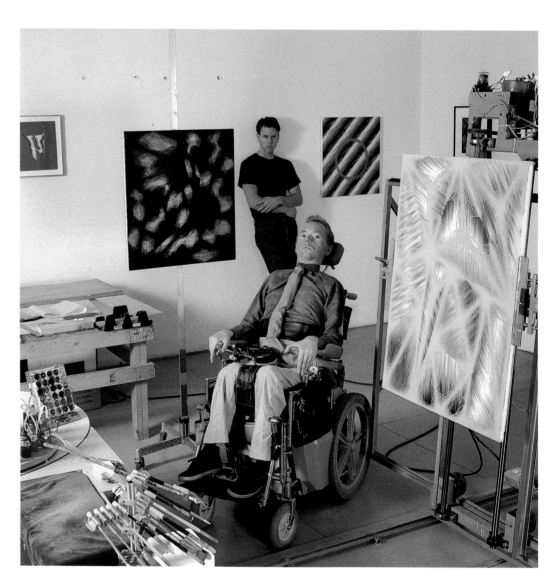

ROBERT IRWIN

In theory my work could be very difficult for the average viewer. In fact, it is very accessible. It's all about how we actually look at the world, and everybody can do that. The only problem for people is the degree to which it does seem not to meet their expectations. But once they release those preconceptions or expectations, the work becomes totally available.

Actually the best way to describe my work is that I attend what I'm doing and take my cues from the immediate world, not from other assumptions I have or historical notions that already exist. What I do is try to make sense out of that. All of my understanding and all of my access and decisions are made according to what I'm actually experiencing. It's a very simple process. So . . . "attending" is the key word in everything I do.

But when I say that, everybody would probably say he was doing the same thing . . . just as everyone feels he sees . . .but we *don't* actually do the same thing. So the real question is, what do we mean by this "seeing," this "attending?"

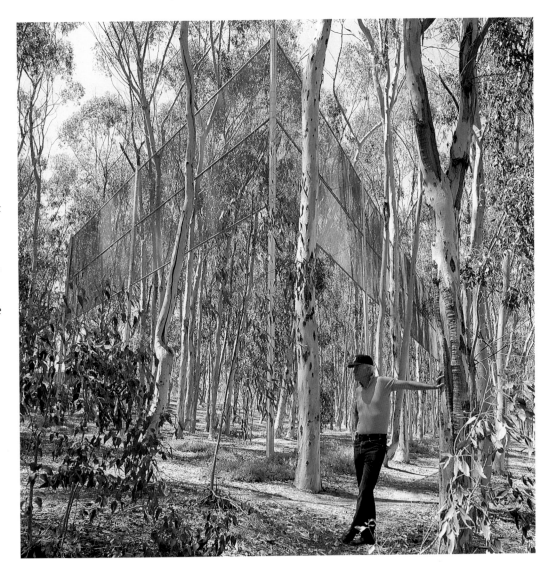

JIM ISERMANN

Pop Art was Popular Culture in 1965. Op Art became paper dresses and black light posters. Warhol was a household word. I learned to drive in a '65 Olds Dynamic 88. I anticipated a suburban life of conveyer belt sidewalks and picture phones.

I was robbed of the promised future by the macrame and chrome and glass nightmare of the 70s. I consume Day-Glo flower key rings, Pop Stickles, Andy Warhol's flowers, fiberglass furniture, and its plastic offspring. I drive a '65 Rambler Marlin and produce ensembles that fulfill my expectations of that lost optimistic ideal.

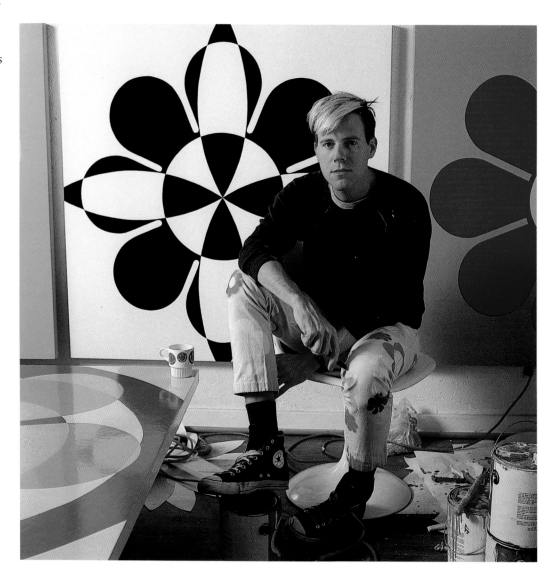

CONNIE JENKINS

My paintings are representational images of rocks on sand. They are also eulogies to people who have died—victims of political violence. Each painting memorializes a specific occasion of death, and each rock an individual civilian killed by the police or the military in El Salvador.

I make these paintings to acknowledge responsibility for these acts, to speak the names of the nameless, to transcend the violence and the guilt, to stand in solidarity with those who must struggle to survive.

A thirteen-year-old child murdered in Soweto. 482 campesinos massacred in El Mozote, nineteen thousand in Lebanon. Each act of violence diminishes us all. I recognize each death as my own.

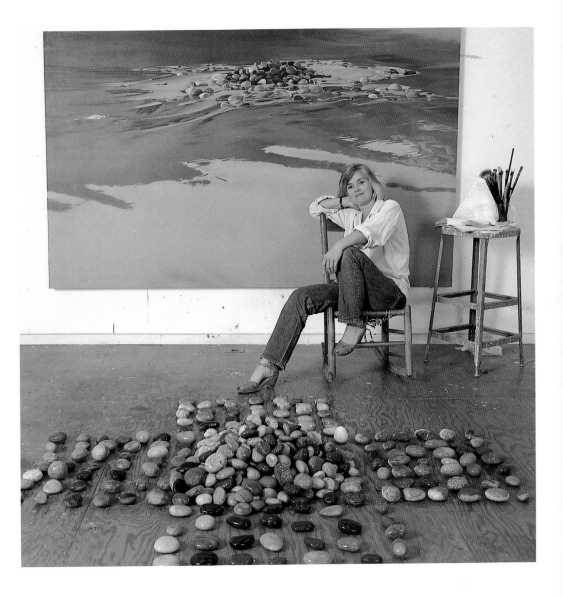

TOM JENKINS

I paint what I see. I see one of the largest toxic landfills in California situated on the San Andreas fault adjacent to the L.A. county water supply reservoir. I see a luxury country club community built on top of a dump. I see boats fishing at the sewage outlets that pass all the waste from Los Angeles into the ocean.

I paint these places backlit with the brilliant sunset colors that only a 3-stage smog alert can produce.

I paint these images from my environment with high gloss, lead-based, synthetic enamels creating a surface to match the image.

I also play a variety of handmade and folk instruments while waiting for the paint to dry.

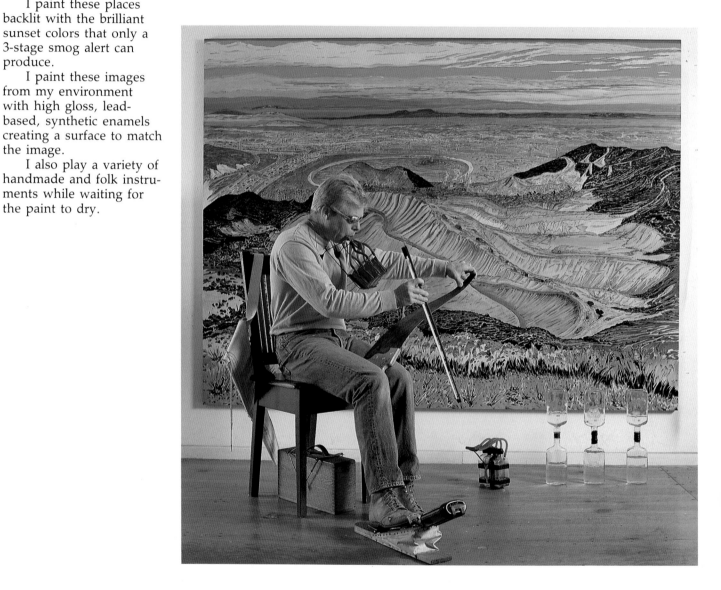

MIKE KELLEY

Note: *Mike Kelley had the strong desire for his photograph to stand alone and speak for itself and him.* —M.M.

HARRY KIPPER

I am not doing any performance art, which is what I'm known for, at the moment. I'm trading commodities, which I'm doing in a way that I also perform with similar compulsion and obsessiveness.

The trading of commodities is a performance for me, because I do a daily live ten minute TV show, and every morning I get prepared for this just like a performance. I put on a costume, I choose particular clothes that I think are likely to attract attention and convey something. I have a collection of ties, and I always carefully choose a tie and shirt that are probably likely to irritate people because they really don't match, they clash horribly. And I wear one of a collection of sort of used-car-salesman suits, and then I get into the character, just like I do in a performance, for this live TV show.

The character is this extremely stern person who doesn't smile at all. Consciously it just has evolved that way. I discovered that this character is quite effective and people really believe me. Not only that, it ended up with me believing myself. It's very strange. And it actually went beyond that. I have a growing reason to believe what I am saying because I see the results that I talk about. I'm actually producing for my clients. So what started out as a pretense has become a very serious thing.

This is business as performance art.

RANDALL LAVENDER

There was a time when art was dominated by religion and mythology—when the content of art reflected shared beliefs and values within a culture. Fortunately, modern thinking exceeded those limitations and came to define art as individual expression. Unfortunately, however, art has not been about real shared belief or experience since that time. It is difficult to sense deep beliefs and values held in common today. Rather, we seem to face a solitary struggle in search of meaning. My work is about that struggle. My figures express the vulnerability inherent in it. They are positioned and grouped to confront us with the mystery of what human beings might be feeling, knowing, or seeking. Although the work appears Academic, it uses that familiar vocabulary of painting style to illuminate its subtext—the dignity of contemporary man.

MARK LERE

My work can be accurately reflected by assembling some "scattered" thoughts:

I always figured in a sense that artists are displaced magicians. They're making these gestures, these objects, that somehow are going to influence something, either a person's thoughts or an action, or even a physical thing. There's some fascination with the ability to do something small in a human sense. I think artists are the kind of people that are mystified by their own ability to make those small gestures.

I think there's a relationship between comedy and very good artwork. It has to do with timing—the timing of a person seeing the work and understanding what it's about. Whether the piece is humorous or not, the timing element is still there: the amount of information that is given opposed to the amount of information that isn't.

If an artwork could be thought of as a word, a triptych or a grouping as a sentence, and an installation as a paragraph . . . what is a story?

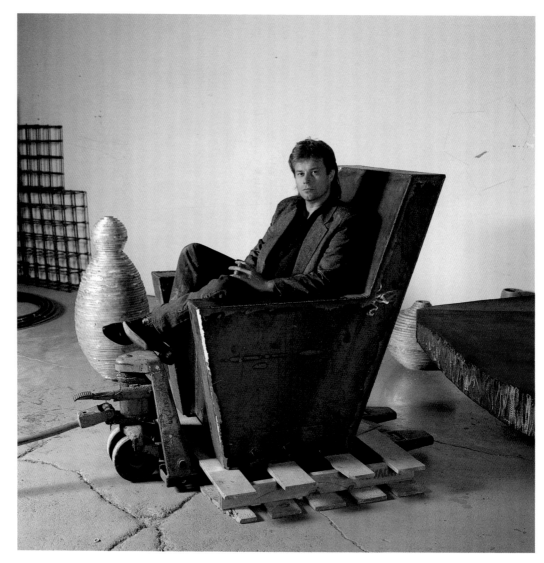

HELEN LUNDEBERG

Although I have been obliged from time to time, to make "statements" about my work, I don't really like to do it; I always hope the work speaks for itself. It seems to me obvious that it is both lyrical and formal and that these elements are inseparable and constant, however much paintings of different periods may appear unlike others, sometimes drastically, in scale, palette and images. The principles remain the same, and certain themes keep recurring in different guises.

I have no interest in merely pleasant "arrangements." My intention is to create poetic entities, in which form and subjective content are one.

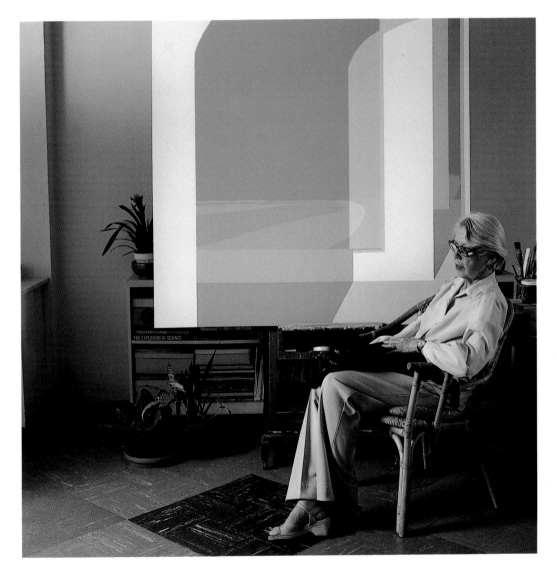

CONSTANCE MALLINSON

Since the beginning of Western painting, landscape painting has always been a means of analyzing the human relationship to nature. Rather than using the deep illusionist space of traditional landscape painting or a "plein-air" approach, the scenes I choose to paint are the clichéd images of postcards, calendars, advertising and picture books.

Juxtaposed, these scenes form a composite contemporary view of nature, or the information bombardment we are continually faced with. The most recent work organizes landscape imagery, all derived from photos, into recognizable shapes such as faces names or figures. These paintings seem to suggest that as we photograph to better understand the world, that is, to concretize our perceptions, these images accumulate and in turn determine who we are as humans.

It is the antithesis of Romantic landscape painting with its notions of a religious sublime. Rather than contemplating the mystical unknown creative source, we are confronted with the claim that we are products of our own limited and fictitious perceptions.

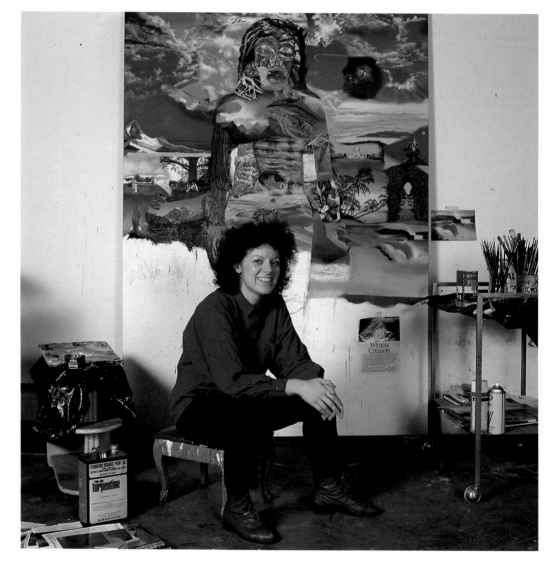

JOHN McCRACKEN

Art is capable of suggesting and helping form advancements in the lives of individuals and in the lives of worlds. Individuals, groups of individuals, planets, even whole planetary systems and star systems can develop to where they themselves are "living works of art," and art can provide some of the sparks leading to and creating such developments. Art in essence is developmental creativity, and so not only can be developed anywhere, in any medium, but also touches, has to do with absolutely ev

I see far ties for thi world, a because possi actu th inte

best of what mankind has done and can do. Accomplishments that seem mere science-fiction dreaming would become possible— not only things such as completely safe handling of atomic energy and a pollution-free environment, but also faster-than-light travel to other stars, and travel to other time planes [and, amazing as it

may seem, adventurous activities that are far more interesting and productive than fighting wars].

On a more immediate level here on this present earth, it is a significant bit of art whenever one person makes a real and positive gain in life. The crux to the whole idea is the individual, and his or her becoming a "true artist."

I try at least to make sculptures that are able to look as if they came from, or "know" of, such advanced possible worlds in our space-time universe of countless galaxies.

MICHAEL McMILLEN

In my installations and sculptures I frequently use discarded materials. This is a poetically deliberate act. To use the analogy of the alchemist or magician (who transform base elements into noble ones or who create matter where none apparently existed before), the artist orchestrates matter to evoke feelings and thoughts in the mind of the viewer.

A theme common to my work is the notion of transmutation and change. That which was once new is presented at some point between its origin and terminus, in the act of constant metamorphosis. The wheel of life shows that the end of one state is but the beginning of another—a process as old as the universe.

Finding discarded objects at the end of their "useful lives" and incorporating them into a new context (as part of a work of art) brings a richness of past and mystery to the newly "born" art work. Ultimately, art is a reflection of the history in which it is created. Now, in the late 20th century, the very possibility of a future and continued existence is a fundamental question to be asked.

But then, perhaps, the very creation of art against such a background is an act of ultimate faith and optimism.

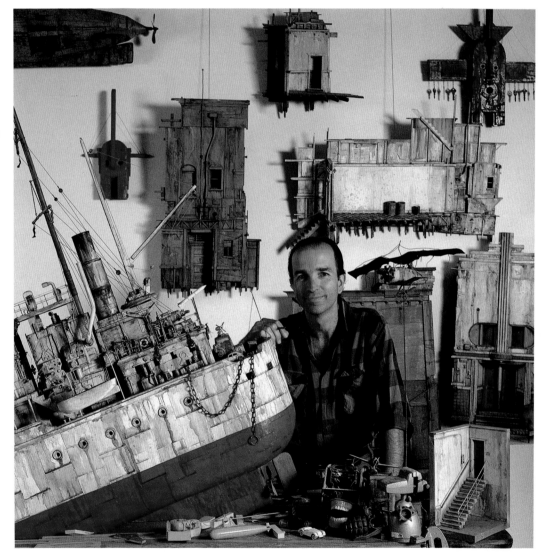

JIM MORPHESIS

The process of painting is a very personal exploration and it should be a mystery that creates a most difficult challenge for those who have the task of describing it through words.

I certainly would prefer to have my paintings speak for themselves. However, being asked to say something about my work, I trust that the following comments on my process and imagery will offer some insight into the origin of my art.

As I was raised in the Greek Orthodox tradition, the imagery of the Byzantine icon has served as a most powerful visual and emotional influence since I began painting.

Also, images from Christian iconography, such as the crucifix, often appear in my paintings and represent, so well, the moral strengths and physical frailties of man, while figures from Hellenic mythology, such as Prometheus, have served a similar purpose in my work. In many recent paintings, the image of a beefy skull more personally represents my own mortality.

While these images have the power to represent great human struggles and allude to the conflicts that we all must face, the real power lies in the act of painting itself. If my paintings are to communicate something of worth, the message must be delivered, primarily, through a painting process that is itself a battle.

In my paintings, the structured image is consumed by gestural, often violent strokes of oil paint and collage materials. The image, buried and resurrected many times within the painting, may finally appear recognizable or lost in abstraction. For me, this process is a search for order while, at the same time, recognizing the need for inevitable chaos.

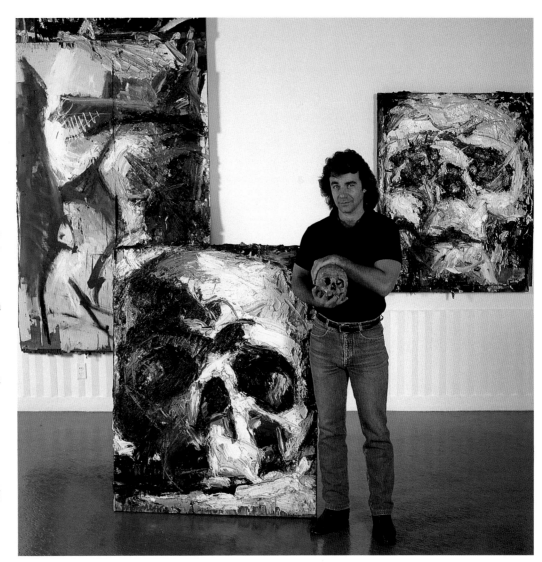

ED MOSES

I am not the kind of guy who fits into people's formats. I like to establish my own format. I'm a rebel without a cause. I have no purpose to what I do, I just do it. I think that a long time ago people who were like that, the magic makers, didn't have to have any particular reason or explanation for what they did; they articulated independently. They weren't usually part of the tribe. They didn't participate in tribal activities. They were off doing something else. The group acts as a group and then there are the weirdos and offbeats. That's what the magic person should be.

The artist should be decorating walls and people's houses. That's what artists do in our culture. That's not what I do. That's not my territory.

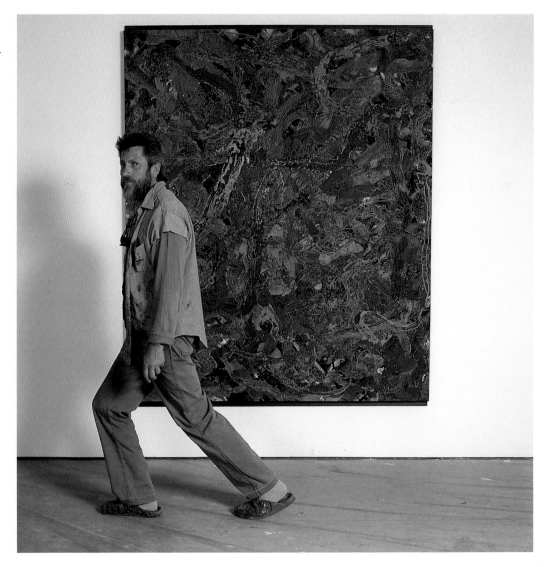

GWYNNE MURRILL

I have always been intrigued by the abstract form of animals, and I've never been interested in doing purely abstract sculpture. I find that the forms in life are so incredibly beautiful. When I see an animal or human being move, something makes me want to show my appreciation for that beauty and to get as close as I can to what that person or creature actually is. I guess the challenge for me is that I can never actually make the form as beautiful as the animal itself. Maybe the strength in my sculpture comes from that struggle, my trying to force it into its own self. I use the abstraction in the movement and also the essence of the animal without exactly rendering it. What you get is a fleeting glance at these animals and their spirits.

I always live far away from the city so what I see in my environment is what I portray. I'm the kind of person who feels there is still some life, some good, left in the world—it's not all destructive. That optimism probably comes across as a slight environmental part in my work, but it's never conscious.

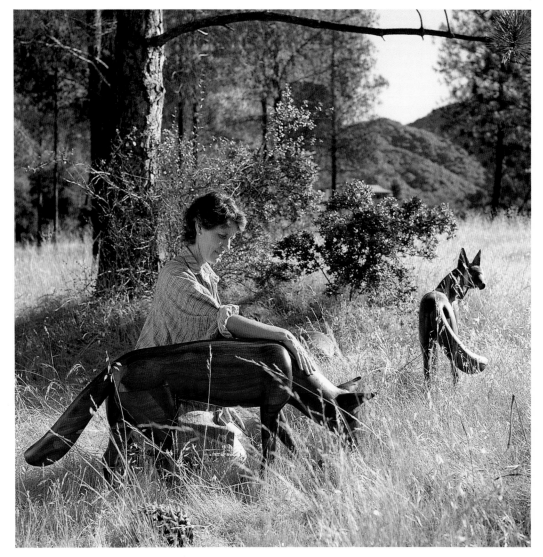

GIFFORD MYERS

When I was a small boy and couldn't sleep, I'd design tree houses, forts, and coasters in my mind until I fell asleep. Things haven't changed much since.

As long as I can remember I've enjoyed making things. I spent hours in the craft shop at the Boys Club. I built a soap box derby car when I was eleven. In college, I tried to direct my interests pragmatically by studying architecture. There were too many others to answer to. Then I found that you could get away with making stuff by calling it art. Now, when people ask me what I do, that's what I tell them. It seems to do the trick.

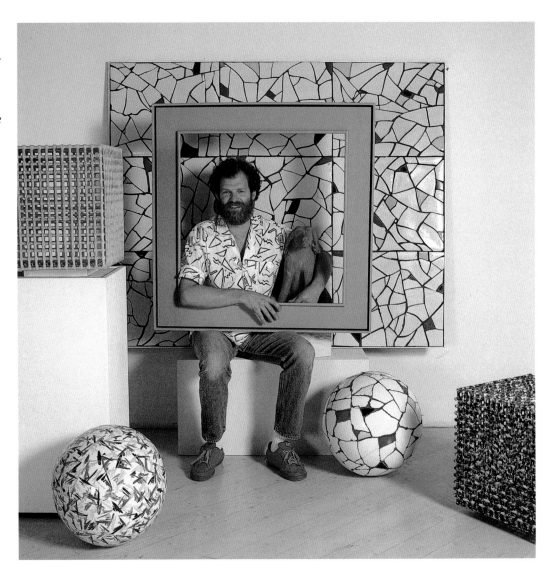

VICTORIA NODIFF

When I was a child in Wisconsin, the local kids and I staked off the front yard into a corral and played "horse." I was the wild horse that the neighborhood roughneck tried to lasso. In my work today I continue to struggle with the conflict of freedom and containment.

I work primarily with images of horses and dogs, because for me animals symbolize a type of freedom and honesty by reacting through instinct. Whatever emotions, experiences, or perceptions I focus on, the animal is the vehicle. On some level, the paintings are self-portraits. When I turned thirty, I painted a quarter horse turning. The horse was standing forward, and had turned to look into an abstracted background. After the painting was finished, I realized that the horse was me moving forward and looking back over my life.

I paint either from photographs I've taken of my own animals or from animals I instinctively connect with. The way I do it, the photographing of the animal is an integral part of the work. If I'm photographing a horse on a lunge line, I might shoot hundreds of exposures over several days before I finally connect with one image.

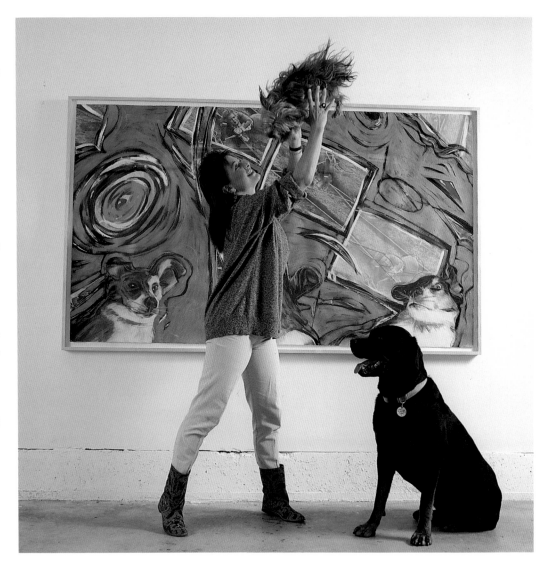

BAILE OAKS

The overall concept of my sculpture is the primal force of life. Not just the animate life of the flora and fauna of our world, but rather the all encompassing dynamic of our biosphere, Earth. Whether the elements are air, fire, water, earth, wood, metal, or the combination thereof that comes together in our own bodies and the bodies of the animals and trees, they are all part of the ever present and ever changing life force of our planet. I work to create symbols that speak to this basic concept that unites all of us in our life together. The inherent movement in the sculpture is alluding to this constant metamorphosis of the elements that come together on our planet.

I want my sculpture to speak of life. However, I also want my sculpture to speak to those additional elements of our society that will help perpetuate our personal lives on this planet. For we are living in perilous times, and even though the earth and its life force will survive, we might cause the demise of our culture and species. Therefore, I want my sculpture to speak of harmony and balance. It is said that when the elements live in harmony and balance within us, we live in a state of being called love. I believe that we will always need symbols in our lives to remind us of this state of being. My goal with my work is to bring more of these symbols into the public domain.

A very important aspect of my work is to create spaces that invite an active participation from the people that visit the site of the sculpture. I create spaces that offer a place of shelter to the visitor, a restful sanctuary.

If my sculpture can instill in people a little more reverence for the force of life that drives our planet, then I will have succeeded with my work.

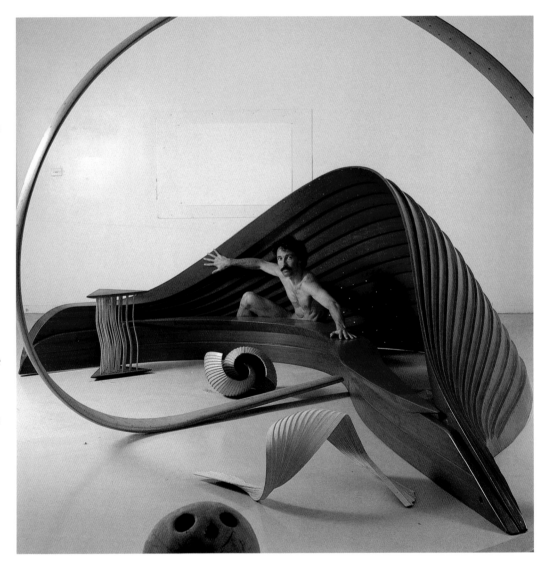

ERIC ORR

To make a work of art as simple as the concept of zero
- I use silence the way a painter uses color
- The artist of the future will address states of mind
- Does transient afternoon light on the wall look better than art?
- Changing the rules IS the game
- I wasn't supposed to mention this, but I live in the void and consider death my oldest friend.

Every now and then, each of us in some small way is allowed a glimpse through the chaos. An edge, a fragment, will briefly dance into place revealing a wholeness, an underlying unity behind the usual disparity.

The desire to re-assemble those moments, to make wholeness out of all the parts, is at once the hook and the carrot. Simultaneously embedded and just out of reach, it spurs the necessity for some visible manifestation, some tangible form.

A funny, jerky little dance which holds the potential for harmonic movement, it is one in which all of us are engaged. Even as we privately tick within our individual skins, so are we nested interacting networks within the larger universal skin, looking for better instructions for the dance, trying to maintain equilibrium through the more complicated and unpredictable steps. I tend to find some of those instructions along the path that art has taken me.

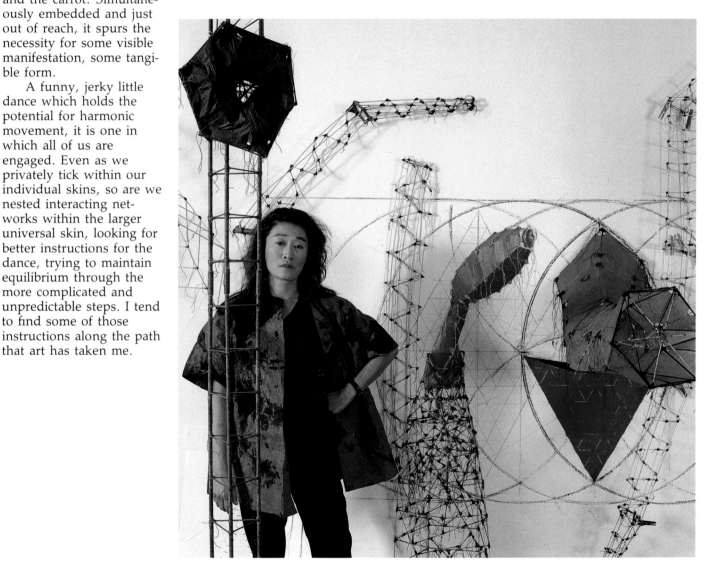

LAURIE PINCUS

For me, making artwork is a process where I flesh out and give form and substance to an imaginary world inside of me. I was an only child, so early on I entertained myself by making up, "discovering," imaginary worlds and people to play with. Giving a form to these people and ideas helps make a bridge between the inner and outer, and so a process I began early on continues with my work today. Inner characters present themselves to me and seem to represent both a personal communication as well as a reflection of and commentary on the "Real" world. I make the characters out of wood and place them in painted moods and settings to tell a story—allowing enough room and mystery to encourage the viewer to project his/her own ideas, feelings and connections to the individual characters, thereby personalizing the dramas being acted out. It is a process not unlike interpreting and responding to symbols in our own and other people's dreams.

Also I like to use a range of sizes so that the viewer, as well as myself, is constantly adjusting his/her perceptions—looking at the small characters in their world allows for a sense of concentration and distance waiting like a toy world for a human relationship/connection to bring it to life. Then when the

same viewer walks into a life-size version of this place and begins to literally rub shoulders with these characters—he/she is now actually inside the artwork—one's relationship to it changes and the viewer becomes part of the story, one of the players. This is very exciting for me because I have really connected one world to the other—I have brought my imaginary people into our "real" world as well as bringing real people into my imagination; and that is what my art work is all about.

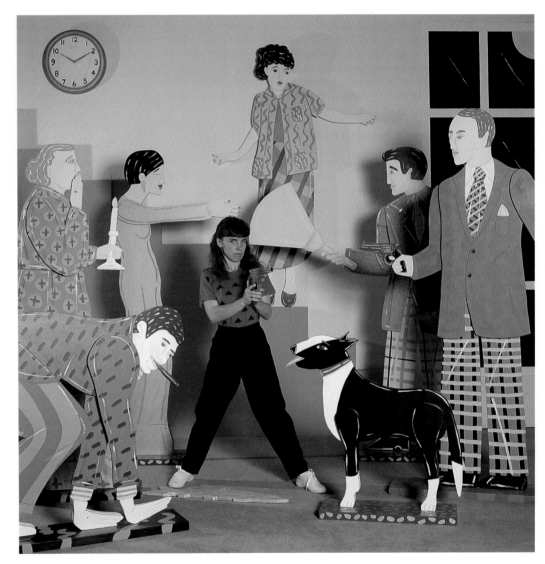

JACK REILLY

I was not one of those kindergarten art prodigies. Daydreaming was my specialty. In fact art, in the formal sense, did not surface in my life until my late teen years. At this time my reveries began to manifest themselves in the form of paintings. I found it difficult, as an adolescent, to pursue what seemed to be a calling to bring my mental images to life through paint. Elements of practicality and financial stability are strongly stressed in our society; this often is the cause for procrastination or abandonment of a creative life. I remember vividly the moment I knew that art is what I had to do. The commitment was made; I was too naive to be scared. It seemed exciting, mysterious, and somehow enlightening.

As an artist I try to share my personal visions and ideals with the viewer. I feel a strong responsibility to communicate as well as investigate my thoughts, although not necessarily in the literal sense. The history of art plays an important role in the development of my work. Great artists such as Leonardo and Rembrandt serve as mentors of a mystical vision that echoes resonantly throughout the ages. My goal is to be a contributing part of this process that is so necessary to life and culture as a whole.

In recent works I have been combining elements of sound, that I compose for certain paintings, with symbolic structures, words, and classical figurative elements. To develop multi-level communication with the viewer is a primary concern. The message in my work, I believe, is open to a variety of interpretations. As the viewer investigates beyond the facade of the flat metallic surfaces, these works may reveal some interesting thoughts about oneself, the fusion of cultures, and the role of art in our contemporary society.

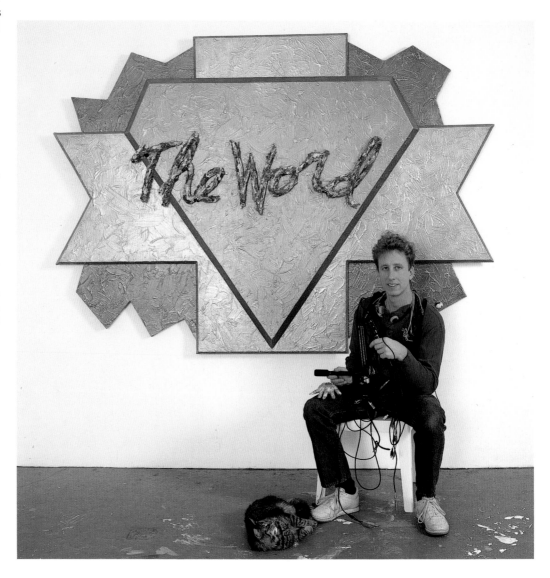

ROLAND REISS

What I notice about my work is that it always and inescapably comes down to some kind of socio-political involvement. I seem to like social and philosophical issues poised in a state of equilibrium. At a more conscious level I am interested in the special conditions of contemporary experience as they relate to space and to objects; what is unique about our way of knowing. My way of getting at it involves multivalency, discontinuity and permutation. Conceptual art has served as a base for my work, although my interest in objects perhaps connects me more specifically to post-conceptual production. My work is produced slowly; it is complicated with a number of territories and levels of meaning. I like indexical signs.

All this stuff requires me to perform like a juggler with too many balls in the air. I like the demand, the discipline and the danger. I want my art to be difficult but accessible and a worthy contribution to contemporary experience.

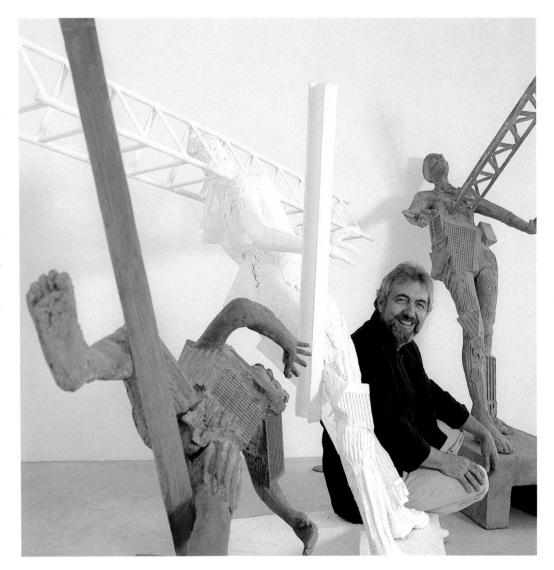

LEO ROBINSON

Most of my themes and ideas come from art history and literature. The images can come from almost anywhere: old prints, photography, films, my life, or the daily newspaper. Sometimes seeing a simple gesture, like someone turning his head or raising a hand, can trigger a painting. I'm interested in basic human situations that represent our collective life, those themes that are constant throughout the history of figurative art. It's historical content and iconography that I personalize by finding a place or a person in my own experience to which I can emotionally anchor the idea. I want my work to be both timeless and contemporary.

Human nature fascinates me. The way people define themselves, relate to one another, and deal with our essential isolation—basic stuff: love, sex, death, religion. For me the challenge is to paint this without irony or criticism.

In much of my work I use a monkey as a trickster character, a symbol of the chaos of life and the desultory events that make it up. I usually put people in ordinary situations, such as answering the phone, and try to suggest that a portentous event has just happened or is about to happen. I rely heavily on suggestion and association.

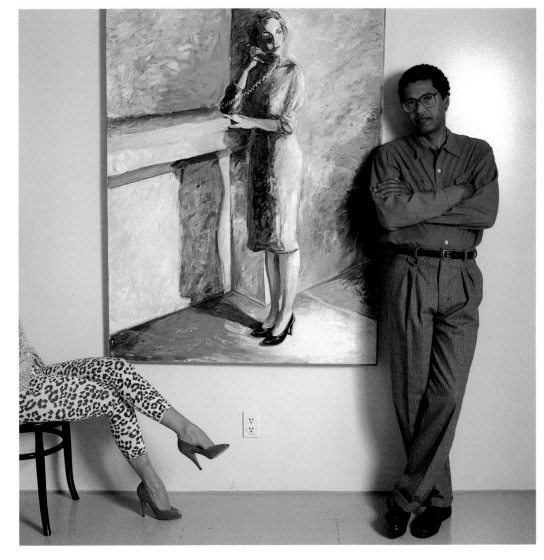

FRANK ROMERO

I love my work. It's fun to make and fun to sell. I've been an artist all my life— I've never done anything else since I was a small child. My earliest recollections are of doing drawings and being an artist. I was accomplished by the time I was in kindergarten.

Like all artists who've done this forever, I sometimes feel I'm just starting. I gave up working for other people six years ago. All I do now is paint, draw, and sculpt, and have endless conferences about selling.

My work is narrative. It's about things, about the way I feel about things— what I feel about art and painting in particular. I'm very much concerned with the way paint is applied, and because it is paint, color.

I am commenting on contemporary culture. A great deal of what I address is about growing up in the southwestern United States, in Boyle Heights, and the dichotomy between life on the east and west sides of Los Angeles.

To me, art is a dialogue between myself and all the artists that have preceded me. Many times I feel I'm talking to Hopper or Picasso, commenting on what they've done in the past. I feel there's something irrepressible about my work. If you look at it closely, a lot of it is about death and suffering and injustice— and yet a joyful spirit pervades the work.

I believe in the Confucian doctrine that says I have a right to be happy.

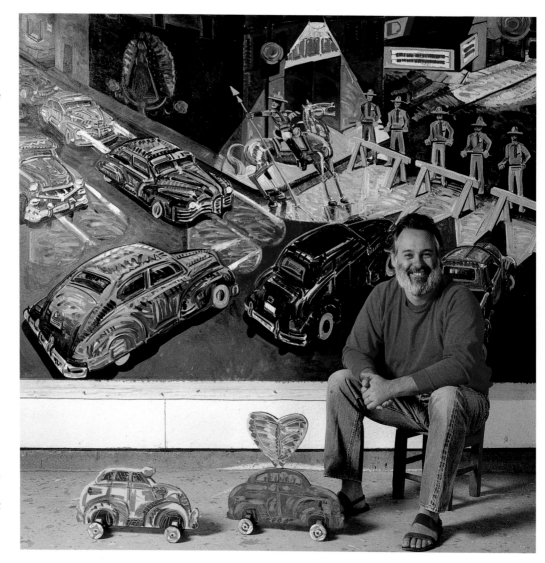

SANDRA
MENDELSOHN RUBIN

While I am called a realist painter, the more I read about the subject, the more confused I am about what that means.

The word realism is defined by the dictionary as the "depiction of things as they really are"—the world of solid objects and "labeled" things. And yet what is real to one person, is different to another. Because, in reality, what we see beyond our bodies is only one small element of the way in which we perceive the world. Our eyes give us a visual summary of what the rest of our senses are interpreting. So what we really "see" is a reading by all our senses, eyes, ears, nose, the tactile, plus the veil of our state of mind, emotions, memory, conscious and subconscious thoughts that color our perceptions of everything.

So what about my realism? For me it is a vehicle to depict both the real and the abstract of life. My pictures come from an internal place before they manifest as images on canvas. Images present themselves through the process of living. Each picture is a kind of poem extracted from life. While they are all painted from life of very specific places and locations, the decision of what to paint and how to paint it comes from inside. And then it is the overall light, mood, tone, or atmosphere that is most important to me. Whether painting an interior landscape or figure, the act of reaching into deep space with paint and brushes, touching the distant intangible and making it magically tangible on the surface of a canvas, is also an act of reaching into deep internal spaces—a kind of "matching up" of those two worlds, one "out there" and one "in here." With-out that inner depth, the pictures would be pointless. Spending months observing and painting something would truly have no meaning. In my ideal mind, I hope that they depict the essence of something, of a feeling that goes beyond the surface of what you see, to an inner place of what you feel.

EDWARD RUSCHA

I keep notebooks. The initial ideas are written out. I don't draw them, I stage them onto the canvas. I had an idea for this drawing called NERVES. I saw it as a capital N and then a lot of space and then ERVES, and in between, a line. I see the thing, and being a good little art soldier, I go and do it. I don't sit there thinking, "Why am I doing this?" There is no answer.

Some ideas are found, ready made; some are dreams; some come from newspapers, books; they're finished by blind faith. No matter if I've seen it on television or in the papers, my mind seems to wrap itself around that "thing" until it's done. It's strange, I don't know what motivates me, but each work is premeditated. I don't stand in front of a blank canvas waiting for inspiration.

BETYE SAAR

My art could be labeled as "visionary." While the work includes formal elements such as form, texture, color, and line, my real concerns are intuitive. I try to communicate emotions, memories, dreams and fantasies.

I have always been attracted to objects—things, discards, and found materials. I like to combine them and transform them into assemblages and collages. I feel this recycling gives my work a sort of power by changing the previous use into another kind of information.

The content of my work has progressed in a somewhat spiral fashion, from ancestral history, to family history, to personal history. Sometimes the themes overlap.

The works are sometimes flat collages or sculptural assemblage, sometimes small and intimate and sometimes room-sized installations.

I feel the strongest aspect of my work is beauty and mystery.

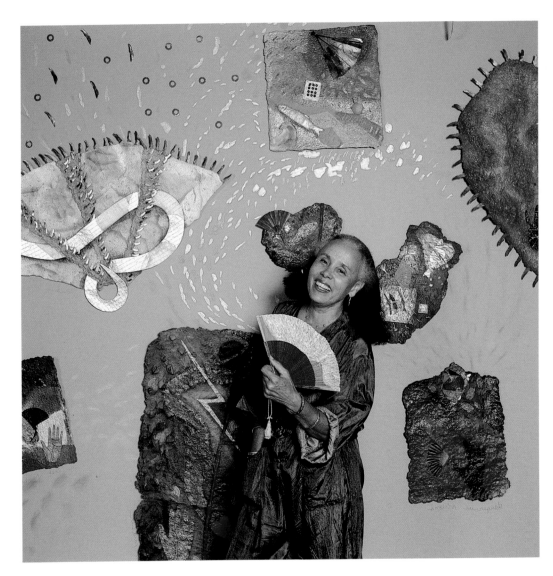

PETER SHELTON

In my early twenties, I lived in a little farmhouse in the country near my birthplace of Troy, Ohio. I was curious about being by myself for awhile though I wasn't really alone. There was a woodchuck in the outhouse and rats in the attic. I worked in a factory in town as a welder, and spent the rest of my time reading, drawing, and dreaming. I soon became a little disoriented. . . .

Looking out my window at a group of cedar trees on the hill in the distance, I would sometimes mistake them for "people" standing in the landscape waiting for me. One night I woke up in a very nervous state. The snow on the fields of battered cornstalks glared with the light of the moon. Those cedars refused to be trees. I set out across the fields to shake my confusion once and for all. Upon my arrival on the hill, I touched each cedar carefully. Yes, these were in fact trees. I could now return to my house for a good night's sleep. Twenty steps away, I turned smugly to reaffirm my sanity. Oh no, "people" again. So I went back up the hill for another round of feeling the trees. Finally after a dozen of these "reality tests," I went home exhausted.

Sculpture is the discipline of such disorientation and exhaustion. It's lucky that we have hands to feel what we see.

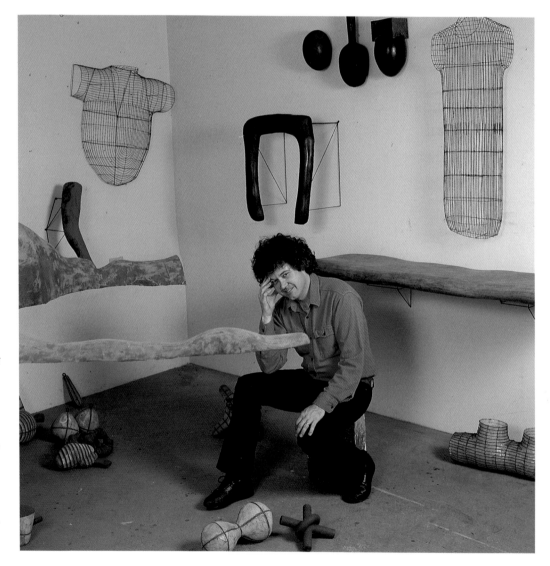

ALEXIS SMITH

My work – collage –
discovering and recycling
words and images and
materials, is the way I
interact with the world.
The act of making art is
for me a means of invest-
ing life with meaning.

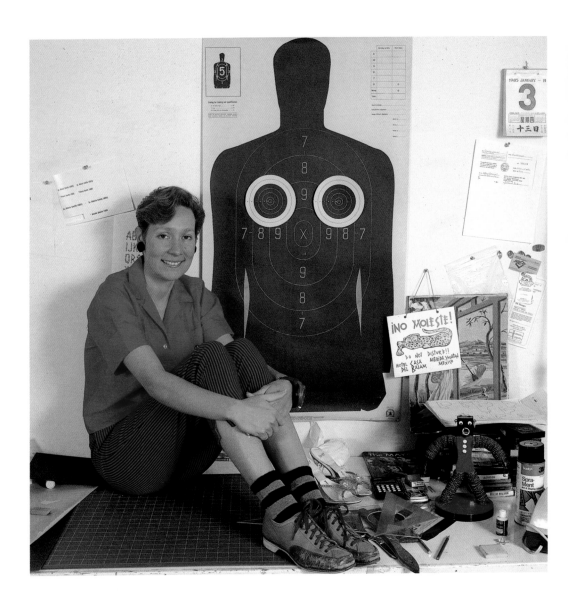

MASAMI TERAOKA

Two entirely different cultural heritages, East and West, are quintessential parts of my work.

The vocabulary of my vision is largely influenced by the Japanese tradition of Ukiyo-e or 17th-19th century woodblock prints. Kunisada and Hokusai particularly have been a constant stylistic inspiration.

Subject matter, on the other hand, especially the pervasive humor in my work, stems from my American living experiences. The American phenomenon of Pop art heavily influenced my earlier works such as my McDonald's Hamburgers and 31 Flavors invading Japan series. Claes Oldenburg's and Tom Wesselman's work made me think in terms of fast food, throwaway culture, and super American consumerism while giving me a new aesthetic perspective.

Presently all of these influences are manifesting themselves in a new theme, the AIDS epidemic. At the same time I am continuously exploring nature in my everlasting obsession with waves.

Irregardless of subject, my compulsion is to create articulate and aesthetically engaging statements of my personal, multi-cultural vision.

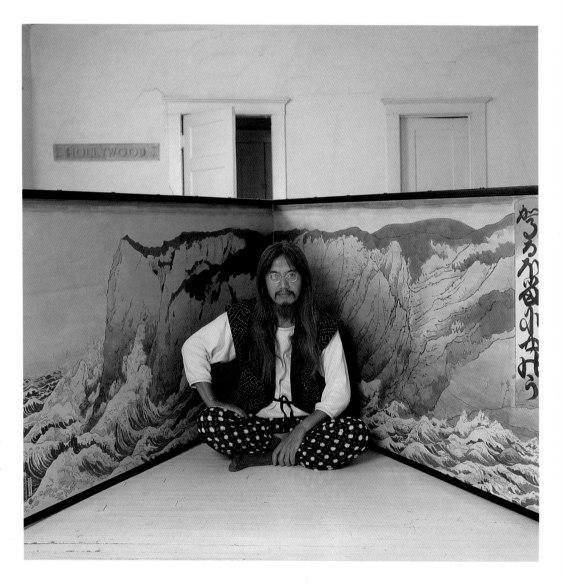

JOYCE TREIMAN

Why do you paint?

In answer to the above
question—why do I
breathe?

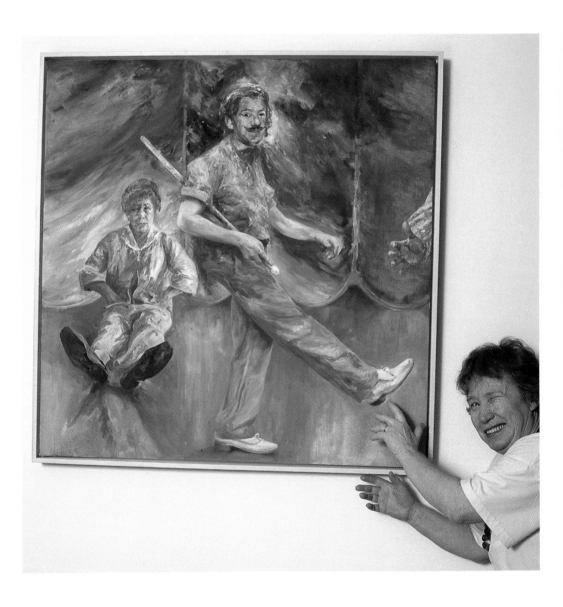

JAMES TURRELL

I seek the physically felt presence of light inhabiting space. The material used is light. Perception is the medium. The work takes place between the physical (creature) limits of perception and the learned (prejudiced) limits of perception. The work is about your seeing. The spaces made are to be plumbed with vision, entered with consciousness.

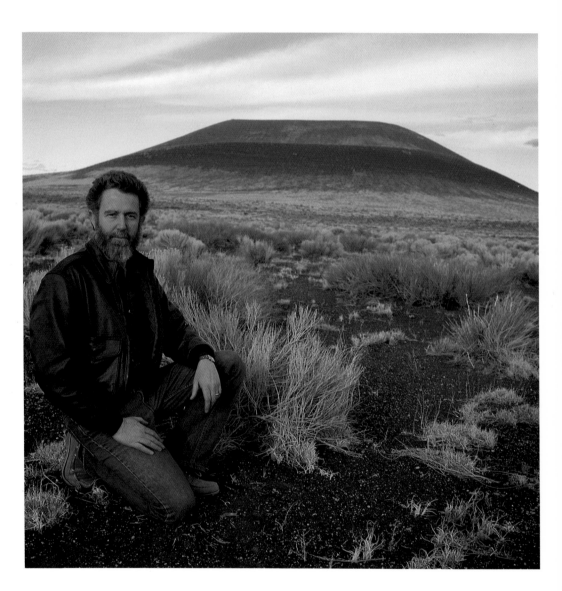

DE WAIN VALENTINE

I have always wanted to be an artist. I am compelled to make art by an inner need. For me this inner need is generated by the force of the spirit of universal love. This is not sophistry. This is not a romantic, sentimental, or filial love, but rather the love of feeling one's self alive. For me this feeling and the making of art are inseparable. I believe this spiritual force expressed as art is the universal uniting element of mankind.

I believe art is the basis of culture and therefore of civilization. It is the pervasive thread that began with the first man and continues into the present and awaits one in the future. I believe art is the core in the logos of the historical continuum.

At the same time this universal spirit of love unites all the arts from prehistory through today. By all the arts I mean performers, composers, poets, writers, architects, photographers, painters, and sculptors. I would group dancers, actors and musicians as performers.

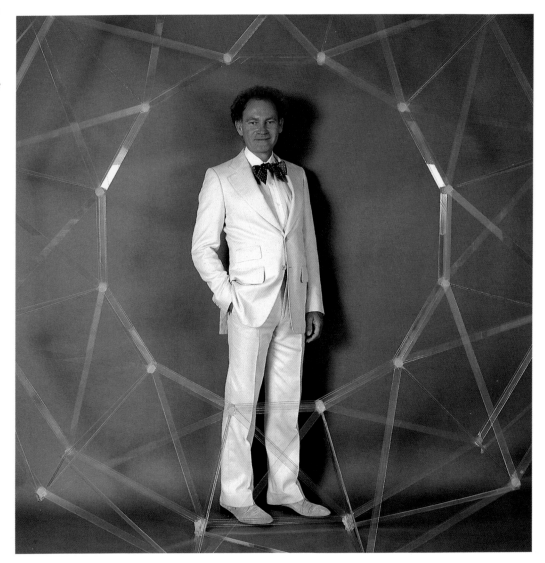

JEFFREY VALLANCE

My work deals with the symbols of society from the ancient to the modern, from primitive carvings to advertising logos. The purity of indigenous designs melt with cross-cultural influences. The images function as emblems of a sacred context that can never be regained. They are symbols of loss, looking appropriately inappropriate.

The work explores the way the surrounding environment produces context for perception. One culture's deity is another's decoration. Local kitsch artifacts mingle in rendition with the most revered objects, to collapse all meaning into one. The technique is intentionally naive and heavy-handed.

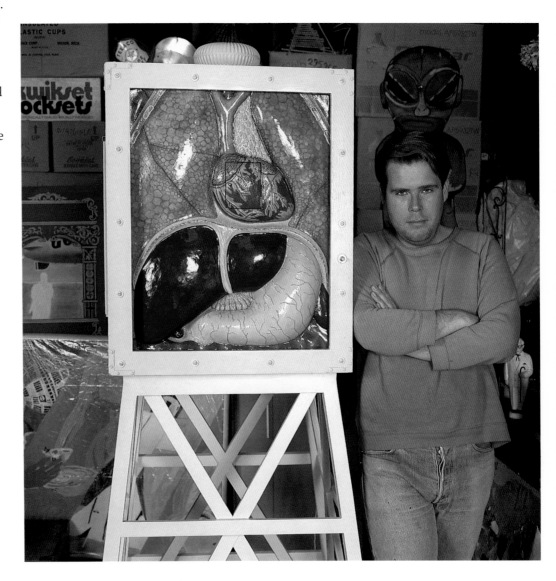

RUTH WEISBERG

My art is neither distanced nor ironic. It is a passionate attempt to give order and meaning to my experiences and perceptions. I think of my canvases as palpable entities on which one sees the flickering images of a heightened reality—one which includes our stories, dreams, memories and visions. Time is the leitmotif of my work in whatever medium—time flowing and time frozen. The cyclical time of generations of men and women is interwoven with the inexorable time of history. The creation of illusion transcends the concreteness of paper, paint, and canvas, just as the human spirit struggles to comprehend time and its inevitable passage.

JOHN WHITE

Most of my art ideas come from direct experiences with daily life. Whether it be from autobiographical sources, social interactions, or impersonal observations from the environment makes no difference to me. This "source material" is then developed in the studio, through a selection process, until I feel it has achieved an appropriate aesthetic form.

MARY WORONOW

Why do I paint? I'm sure the first reason wasn't even mine. It went something like this: "Mary, take these crayons over there and be quiet." I was six then. Around sixteen, I changed it to, "I don't want to talk to you, I'm drawing instead." Now, of course, I can't imagine not painting. It would be like taking a vow of silence — very unnatural.

TOM WUDL

The theme of my work is balance, harmony. That's what I strive for. I use photographs for reference, but alter colors and forms to make sure everything is harmonious. The titles of the big paintings are all "Veils"—"The Painted Veil." In them, the world appears to be real, solid, and it's not at all. That's the feeling I'd like the viewer to have. The device that I use to heighten that perception is an aerial perspective. That way the viewer might feel like he/she is floating.

Some people walk in and see these paintings and they feel themselves disembodied. Another response is that they're dreams. There's a sense of space and light that's deliberately created to put you in a dreamy kind of state. Some people find these dreams disturbing although that's not my intention.

When I sit down at the easel in front of a painting, I think of a musician that's sitting down and rehearsing music that was written a long time ago but has to be assessed and interpreted by these hands today.

SELECTED BIOGRAPHIES

LARRY ALBRIGHT *Exhibitions:* 1986, "Bottled Lightning," Museum of Neon Art, Los Angeles, CA.; 1985, Sculpture, Ross Freeman Gallery, Los Angeles, CA. *Consultant for Motion Picture Special Effects:* 1984, *My Science Project;* 1982, *The Man With Two Brains;* 1981, *One From The Heart;* 1980, *Battle Beyond The Stars;* 1978, *Star Trek: The Motion Picture, Part I;* 1977, *Close Encounters Of The Third Kind. Guest Curator:* 1979, "Neon Prince or Frog," Riverside Art Center, Riverside, CA.

LITA ALBUQUERQUE *Exhibitions, Solo:* 1989, Career Survey, sponsored by the Los Angeles Fellows of Contemporary Art, Los Angeles, CA.; 1988, Richard Green Gallery, New York, NY.; 1986, Saxon-Lee Gallery, Los Angeles, CA.; 1984, Marianne Deson Gallery, Chicago, IL.; 1981, 1979, 1977, Janus Gallery, Los Angeles, CA.; 1980, Diane Brown Gallery, Washington, D.C.; 1976, Jack Glenn Gallery, Newport Beach, CA. *Group:* Amerika Haus, Berlin, West Germany; National Gallery of Modern Art, New Delhi, India; Asahi Shimbun, Tokyo, Japan; American Center, Paris, France; Museum of Contemporary Art, Los Angeles, CA.; Musee d'Art de la Moderne Ville de Paris, Paris, France (also Ireland, Poland); Museum of Modern Art, San Francisco, CA.; Hirshhorn Museum, Washington, D.C. *Awards/Grants:* 1984, 1983, 1975, National Endowment for the Arts. *Collections:* Los Angeles County Museum of Art, Los Angeles, CA.

PETER ALEXANDER *Exhibitions, Solo:* 1987, 1986, 1985, 1981, James Corcoran Gallery, Los Angeles, CA.; 1985, 1984, 1982, Charles Cowles Gallery, New York, NY.; 1983, Municipal Art Gallery, Los Angeles, CA. *Group:* 1987, "Prints by Los Angeles Artists," Asahi Shimbun Gallery, Tokyo, Japan; "Los Angeles Today: Contemporary Visions," Amerika Haus, Berlin, West Germany; 1986, "Selected Works in the Twentieth-Century Art Collection," Los Angeles County Museum of Art, Los Angeles, CA.; 1985, "Spectrum Los Angeles," Hartje Gallery, Berlin, West Germany (catalog); "Made In India," Museum of Modern Art, New York, NY.; 1984, "An International Survey of Recent Painting and Sculpture," Museum of Modern Art, New York, NY. (catalog); 1982, Museum of Modern Art, Paris, France.

MARTHA ALF *Exhibitions, Solo:* 1986, Tortue Gallery, Santa Monica, CA.; 1985, 1976-1984, Newspace Gallery, Los Angeles, CA.; 1984, Los Angeles Municipal Art Gallery, Los Angeles, CA. (also traveled to Art Institute, San Francisco, CA.); 1980, Fort Worth Art Museum, Fort Worth, TX. *Group:* 1985, Henry Art Gallery, Univ. of Washington, Seattle, WA. *Awards/Grants:* 1979, National Endowment for the Arts Grant; Kay Neilsen Purchase Award, Los Angeles County Museum of Art, Graphic Arts Council. *Collections:* Los Angeles County Museum of Art, Los Angeles, CA.; San Diego Museum of Art, San Diego, CA.; Santa Barbara Museum of Art, Santa Barbara, CA.

CARLOS ALMARAZ *Exhibitions:* 1987, "Hispanic Art in the United States," Museum of Fine Arts, Houston, TX.; 1986, Jan Turner Gallery, Los Angeles, CA.; 1985, Fuller Goldeen Gallery, San Francisco, CA.; 1984, "Content: A Contemporary Focus, 1974-1984," Hirshhorn Museum, Washington, D.C.; 1984, "Automobile and Culture," Museum of Contemporary Art, Los Angeles, CA.; 1984, "Aqui," Fisher Gallery, Univ. of Southern California, Los Angeles, CA.; 1984, Janus Gallery, Los Angeles, CA.; 1983, La Jolla Museum of Art, La Jolla, CA.; 1982, "Urban Myths: Paintings," Arco Center for Visual Art, Los Angeles, CA. *Awards/Grants:* 1985, Kay Neilsen Award.

DAVID AMICO *Exhibitions, Solo:* 1987, Ace Contemporary Exhibitions, Los Angeles, CA.; 1982, "Sonata," Newport Harbor Art Museum, Newport Beach, CA. *Group:* 1986, "Four Painters," Flow Ace Gallery, Los Angeles, CA.; 1984, "First Newport Biennial 1984: Los Angeles Today," Newport Harbor Art Museum, Newport Beach, CA.; "New American Painting: A Tribute to James and Mari Michener," Huntington Art Gallery, Univ. of Texas, Austin; 1983, "The First Show: Painting and Sculpture from Eight Collections, 1940-1980," Museum of Contemporary Art, Los Angeles, CA.; 1982, "New Figuration in America," Milwaukee Art Museum, Milwaukee, WI.; 1981, "Between The Freeways: The New Art of Downtown L.A.," Madison Art Center, Madison, WI.; 1980, "We Are Very Kind," Vanguard Gallery, Los Angeles, CA.; 1976, "Month of Sundays," P.S.1, Long Island City, NY.

CHARLES ARNOLDI *Exhibitions:* 1987, Art Museum, California State Univ., Long Beach, Long Beach, CA.; 1987, 1986, 1985, Charles Cowles Gallery, New York, NY.; Hansen-Fuller-Goldeen Gallery, San Francisco, CA.; 1987, 1981-l985, James Corcoran Gallery, Los Angeles, CA.; 1987, 1983, 1981, 1979, 1977, Texas Gallery, Houston, TX.; 1986, Arts Club of Chicago, Chicago, IL. (catalog); 1986, Kansas City Gallery of Art, Kansas City, MO.; 1984, "Charles Arnoldi: Unique Prints," Los Angeles County Museum of Art, Los Angeles, CA.; 1977-79, 1975, Nicholas Wilder Gallery, Los Angeles, CA.; 1971, Riko Mizuno Gallery, Los Angeles, CA.

DON BACHARDY *Exhibitions:* 1980, Robert Miller Gallery, New York, NY.; 1980, James Corcoran Gallery, Los Angeles, CA.; 1974, The New York Cultural Center, New York, NY.; 1973, Municipal Art Gallery, Los Angeles, CA.; 1964, DeYoung Museum, San Francisco, CA. *Collections:* Metropolitan Museum of Art, New York, NY.; University of Texas, Austin, TX.; Univ. of California, Los Angeles, CA.; Fogg Art Museum, Harvard University, Cambridge, MA.; Princeton University, Princeton, NJ.; National Portrait Gallery, London, England.

JOHN BALDESSARI *Exhibitions, Solo:* 1987, Centre Nationale d'Art Contemporain de Grenoble, Grenoble, France; 1986, 1984, Margo Leavin Gallery, Los Angeles, CA.; 1986, 1984, 1981, 1980, 1975, Sonnabend Gallery, New York, NY. (also Paris, France, 1973); l981-82, "John Baldessari: Work 1966-1980," The New Museum, New York, NY. (traveled to The Contemporary Arts Center, Cincinnati, OH. and Contemporary Arts Museum, Houston, TX.); 1985, Site-Specific Billboard Project, organized by Bureau of Culture, Middelburg, West Germany. *Group:* 1987-1988, "Photography and Art: 1946-1986," Los Angeles County Museum of Art, Los Angeles, CA. (also, Museum of Art, Fort Lauderdale, FL.; Queens Museum, Flushing, NY.); 1987, "Avant-Garde in the 80s," Los Angeles County Museum of Art; 1986-1988, "Individuals: A Selected History of Contemporary Art, 1945-1986," Museum of Contemporary Art, Los Angeles, CA.; 1985-1986, "Carnegie International: Contemporary Art—Europe and America in Pittsburgh," Museum of Art, Carnegie Institute, Pittsburgh, PA.

LARRY BELL *Exhibitions, Solo:* 1986, Galerie Gilbert Brownstone & Cie., Paris, France; 1985, "Larry Bell: New Sculpture" and "Larry Bell: Vapor Drawings on Paper and Glass," L.A. Louver Gallery, Venice, CA.; 1982, "Larry Bell, the Sixties," Fine Arts Museum, Santa Fe, NM.; Marion Goodman/Multiples Gallery, New York; 1974, Marlborough Galleria D'arte, Rome, Italy (travelled to Torino, Verona, Venice, and Milano); 1970, Galerie Rudolf Zwirner, Cologne, Germany; 1970-1973, 1967, 1965, Pace Gallery, New York, NY.; Stedelijk Museum, Amsterdam, Holland; Galeria Ileana Sonnabend, Paris, France. *Group:* 1986, 1981, 1979, 1969, 1967, 1965, Museum of Modern Art, New York, NY.; 1976, 1974, 1967, Whitney Museum of American Art, New York, NY.; 1986, 1984, Museum of Contemporary Art, Los Angeles, CA. *Collections:* Centre Georges Pompidou, Paris, France; Guggenheim Museum, New York, NY.; Hirshhorn Museum, Washington, D.C.; Los Angeles County Museum of Art, Los Angeles, CA.; Museum of Modern Art, New York, NY.; National Collection of Fine Arts, Smithsonian Institution, Washington, D.C.; Stedelijk Museum, Amsterdam, Holland; Whitney Museum of American Art, New York, NY.

BILLY AL BENGSTON *Exhibitions:* 1988, Retrospective exhibit, Contemporary Art Museum, Houston, TX. (also Oakland Museum, Oakland, CA. and Los Angeles County Museum of Art, Los Angeles, CA.); 1987, James Corcoran Gallery, Los Angeles, CA.; 1987, Thomas Babeor Gallery, La Jolla, CA.; 1981, Texas Gallery, Houston, TX.; 1981, Acquavella Contemporary Art, Inc., New York, NY.; "Billy Al Bengston, Watercolors 1974-1980," Corcoran Gallery of Art, Washington, D.C. (illustrated catalog with text by Jane Livingston, design by Billy Al Bengston); "A Decade of Billy A. Bengston: The Seventies," San Diego State Univ., San Diego, CA. (illustrated catalog with text by Jeff Perrone). *Collections:* Museum of Modern Art, New York, NY.; Los Angeles County Museum of Art, Los Angeles, CA.; Whitney Museum of American Art, New York, NY.

TONY BERLANT *Exhibitions:* 1988, L. A. Louver Gallery, Venice, CA.; 1987, Municipal Art Gallery, Los Angeles, CA.; 1987, John Berggruen Gallery, San Francisco, CA.; 1986, Xavier Fourcade, Inc., New York, NY.; 1982, Contemporary Arts Museum, Houston, TX.; 1982, Los Angeles County Museum of Art, Los Angeles, CA.; 1978, Texas Gallery, Houston, TX.; 1975, James Corcoran Gallery, Los Angeles, CA.; 1974, Phyllis Kind Gallery, Chicago, IL.; 1973, "The Marriage of New York and Athens," Whitney Museum of American Art, New York, NY.; 1967, David Stuart Gallery, Los Angeles, CA.

ROGER BOGGS *Exhibitions:* 1987, Mannsfield Art Center, Mannsfield, OH.; 1987, A.R.T. Beasley Gallery, San Diego, CA.; 1987, 1971, Cleveland Art Museum, Cleveland, OH.; 1986, Michael Ivey Gallery, Los Angeles, CA.; 1985, Eilat Gordon Gallery, Los Angeles, CA.; 1985, Cobalt Blue, Los Angeles, CA.; 1979-80, Ventura County Art Museum, Ventura, CA. *Collections:* Kent State University, Kent, OH.; FHP: Long Beach, CA., Salt Lake City, UT., Guam.

WILLIAM BRICE *Exhibitions:* 1986, Grey Art Gallery, New York Univ., New York, NY.; 1986, Museum of Contemporary Art, Los Angeles, CA.; 1985, Tyler School of Art, Temple Univ., Philadelphia, PA.; 1984, L.A. Louver Gallery, Venice, CA.; 1984, 1980, Robert Miller Gallery, New York, NY.; 1967, Museum of Modern Art, San Francisco, CA.; Dallas Museum of Art, Dallas, TX. *Collections:* Museum of Modern Art, New York, NY.; Whitney Museum of American Art, New York, NY.; Metropolitan Museum of Art, New York, NY.

DAVID BUNGAY *Exhibitions, Solo:* 1987, Jan Turner Gallery, Los Angeles, CA. (also 1985, group); 1984, 1982, Janus Gallery, Los Angeles, CA.; 1976, University of California, Irvine, CA.; Morgan Thomas Gallery, Santa Monica, CA. *Group:* 1987, Einstein Gallery, New York, NY.; 1984, Design Center, Los Angeles, CA.; 1957-1968, Pasadena Art Museum, Pasadena, CA. (also Los Angeles County Museum of Art, Los Angeles, CA.; San Francisco Museum of Art, San Francisco, CA.

HANS BURKHARDT *Exhibitions:* 1987, 1985, 1982, Jack Rutberg Fine Arts, Los Angeles, CA.; 1987, Sid Deutsch Gallery, New York, NY.; 1984-85, Terra Museum of American Art, Evanston, IL. (traveled to Oklahoma Museum of Art, Oklahoma City, OK., Toledo Museum of Art, Toledo, OH., Elvehjem Museum of Art, Univ. of Wisconsin, Madison, WI.; National Academy of Design, Washington, D.C.); 1984, Hirshhorn Museum, Washington, D.C. (traveled to Milwaukee Art Museum, Milwaukee, WI., J. B. Speed Art Museum, Louisville, KY.); 1982-83, 1980, 1951, 1947, Corcoran Gallery, Washington, D.C.; 1980, 1959, 1956, 1954, 1952, 1945, Los Angeles County Museum of Art, Los Angeles, CA.; 1976-77, San Francisco Museum of Art, San Francisco, CA.; National Collection of Fine Arts, Smithsonian Institution, Washington, D.C.; 1972, "Retrospective 1950-1972," Long Beach Museum of Art, Long Beach, CA.; 1961-62, 30 Year Retrospective, Santa Barbara Museum of Art, Santa Barbara, CA. (also, Palace of the Legion of Honor, San Francisco, CA.; Municipal Art Gallery, Los Angeles, CA.); 1958, 1955, 1952, 1951, Whitney Museum of American Art, New York, NY.; 1952, 1948, Chicago Art Institute, Chicago, IL.

RICHARD CAMPBELL *Exhibitions:* DeYoung Museum, San Francisco, CA.; Los Angeles County Museum of Art, Los Angeles, CA.; Pittsburgh Plan for Art, Pittsburgh, PA.; Denver Museum, Denver, CO.; Butler Institute of American Art, Youngstown, OH.; Univ. of California at Los Angeles, Los Angeles, CA.

KAREN CARSON *Exhibitions, Solo:* 1980-87, Rosamund Felsen Gallery, Los Angeles, CA.; 1976-77, 1973, Cirrus Gallery, Los Angeles, CA. *Group:* 1983, "The First Show," Museum of Contemporary Art, Los Angeles, CA. (catalog); 1982, "L.A. Art: An Exhibition of Contemporary Paintings," Nagoya City Museum, Nagoya, Japan (also, Municipal Art Gallery, Los Angeles, CA.); 1981, "Abstractions," San Francisco Art Institute, San Francisco, CA.; 1979, L. A. Drawing Show, Univ. of New Mexico Art Gallery, Albuquerque, NM.; 1978, "A Point of View," Los Angeles Institute of Contemporary Art, Los Angeles, CA.; 1975, "Graphics," Cirrus, Van Stratten Gallery, Chicago, IL. *Awards/Grants:* 1981, Recipient Painting Fellowship, John Simon Guggenheim Memorial Foundation.

MARY CORSE *Exhibitions, Solo:* 1988, Oil and Steel Gallery, Los Angeles, CA.; 1987, Adams Middleton, Dallas, TX.; 1986-88, ACE Gallery, Los Angeles, CA.; 1981, The Clocktower, New York, NY.; 1979-83, Janus Gallery, Los Angeles, CA.; 1974-75, Richard Bellamy Gallery, New York, NY.; 1972 Joe Lo Guidice Gallery, New York, NY. *Group:* 1987, Newport Harbor Art Museum, Newport Beach, CA.; 1986, Art Fair, Basel, Switzerland; 1983, "Young Talent Awards: 1963-1983," Los Angeles County Museum of Art, Los Angeles, CA.

DENNIS CURTIS *Exhibitions, Solo:* 1986, 1984, Double Rocking "G" Gallery, Los Angeles, CA.; 1976, Nexus Gallery, Los Angeles, CA.; 1972, Horizon Gallery, Venice, CA.; 1964, Walpurgis Gallery, Hoboken, NJ. *Group:* 1981, F. S. Wright Gallery, MFA Show, Los Angeles, CA.; 1965, Yellow Kid Gallery, New York, NY.

MELVIN DETROIT *Exhibitions:* 1983-85, Rose Cafe, Venice, CA.; 1984, "New Furniture," Angles Gallery, Santa Monica, CA.; 1984, "Olympic Sports Furniture," Whitely Gallery, Los Angeles, CA.; 1983, "Constructions," Gensler Assoc., Los Angeles, CA.; 1983, Art Space, Los Angeles, CA.; 1981, "The Designers Art," Art Center College of Design, Pasadena, CA.; 1979, "On Fabric," Security Pacific Bank, Los Angeles, CA.; 1979, Pacifica Exhibition Award, Los Angeles, CA.; 1978, The New Fabric Surface, Smithsonian Invitational, Washington, D.C.; 1976 California Design, Los Angeles, CA.

RICHARD DIEBENKORN *Exhibitions:* 1977-1986, M. Knoedler & Co., New York, NY. (also, Stanford Univ., Palo Alto, CA.; Washington Gallery of Modern Art, Washington, D.C.; The Jewish Museum, New York, NY.; Waddington Galleries, London, England; San Francisco Museum of Art, San Francisco, CA.; Marlborough Gallery, New York, NY.; Brooklyn Museum, Brooklyn, NY., Switzerland, etc.); 1981, "Matrix/Berkeley 40," University Art Museum, Berkeley, CA.; "Richard Diebenkorn: Etchings and Drypoints," (travelled to Minneapolis Institute of Art, Minneapolis, MN.; Atkins Museum of Fine Art, Kansas City, MO.; Saint Louis Art Museum, St. Louis, MO.; Biltmore Museum of Art, Baltimore, MD.; Carnegie Institute,

Pittsburgh, PA.; The Brooklyn Museum, Brooklyn, NY.; Flint Institute of Art, Flint, MI.; Springfield Art Museum, Springfield, MO.; Univ. of Iowa Museum of Art, Iowa City, IA., Univ. of Houston, Houston, TX.; Newport Harbor Art Museum, Newport Harbor, CA.; Museum of Modern Art, San Francisco, CA.; Marlborough Gallery, New York, NY.); 1976, "Richard Diebenkorn: Paintings and Drawings, 1943-1976," (travelled to Albright-Knox Art Gallery, Buffalo, NY.; Cincinnati Art Museum, Cincinnati, OH.; Corcoran Gallery of Art, Washington, D.C.; Whitney Museum of American Art, New York, NY.; Los Angeles County Museum of Art, Los Angeles, CA.; Oakland Museum, Oakland, CA.). Collections: Corcoran Gallery of Art, Washington, D.C.; Guggenheim Museum, New York, NY.; Hirshhorn Museum, Washington, D.C.; Los Angeles County Museum of Art, Los Angeles, CA.; Metropolitan Museum of Art, New York, NY.; Museum of Modern Art, New York, NY.; Whitney Museum of American Art, New York, NY.

GUY DILL Exhibitions, Solo: 1987, 1986, 1984, 1983, 1977, 1973, 1971, Ace Gallery, Los Angeles, CA.; 1974-76, Pace Gallery, New York, NY. Group: 1984-85, "California Sculpture Show," Stadtiche Kunsthalle, Mannheim, West Germany (also, CAPC, Bordeaux, France; Yorkshire Sculpture Park, West Bretton, England; Sonja Henies OG NIELS ONSTADS, Hovikodden, Norway); 1981-1982, "Anthony Caro, Guy Dill, Michael Heizer, Robert Rauschenberg," (sculptors), Ace Gallery, Los Angeles, CA.; 1980, "Across The Nation, Fine Art for Federal Buildings 1972-79," National Collection of Fine Arts, Smithsonian Institution, Washington, D.C.; 1978, "Sculpture from the Permanent Collection," Museum of Modern Art, New York, NY.; 1974, "American Show," Chicago Art Institute, Chicago, IL.; 1973, "Biennial," Whitney Museum of American Art, New York, NY.; 1972, "The Odoron Show," Guggenheim Museum, New York, NY.; 1971, "Acquisitions," Pasadena Art Museum, Pasadena, CA.

LADDIE JOHN DILL Exhibitions, Solo: 1986, Long Beach Museum of Art, Long Beach, CA.; 1986, 1983, 1982, 1977-1980, James Corcoran Gallery, Los Angeles, CA.; 1983, Charles Cowles Gallery, New York, NY.; 1982, Los Angeles Institute of Contemporary Art, Los Angeles, CA.; 1971, Sonnabend Gallery, New York, NY.; Pasadena Art Museum, Pasadena, CA. Group: Govett Grewster Art Gallery, New Plymouth, New Zealand; Museum of Modern Art, San Francisco, CA.; Galerie d + c Mueller-Roth, Stuttgart, West Germany; Nagoya City Museum, Nagoya, Japan; Museum of Contemporary Art, Los Angeles, CA.; Yurakucho Asahi Gallery, Tokyo, Japan (traveling exhibit). Awards/Grants: 1983, California Arts Council, Art in Public Buildings Program Grant; 1982, National Endowment for the Arts, Artists Fellowship; 1979, John Simon Guggenheim Fellowship; 1975, National Endowment for the Arts, Artists Fellowship.

JAMES DOOLIN Exhibitions, Solo: 1986, 1984, Koplin Gallery, Los Angeles, CA.; 1985, Univ. of Southern California Atelier Gallery, Santa Monica, CA.; 1978-79, Traveling Exhibition "Shopping Mall 1973-1977, A Conceptual Perspective," Victorian College of the Arts, Melbourne, Australia, and five other Australian cities; 1977, Municipal Art Gallery, Los Angeles, CA. Group: 1986, "Landscape, Seascape, Cityscape, 1960-1985," Contemporary Art Center, New Orleans, LA. and Academy of Fine Arts, New York, NY.; 1984, "A Broad Spectrum, Contemporary Los Angeles Painters and Sculptors '84," Design Center, Los Angeles, CA.; 1977, "Cityscapes: San Francisco and Los Angeles," DeYoung Museum Downtown Center, San Francisco, CA.; 1968, "The Field," survey exhibition, Victoria National Gallery, Melbourne, and the Art Gallery of New South Wales, Sydney, Australia. Awards/Grants: 1981-1985, National Endowment for the Arts Grants in Painting; 1980, Guggenheim Foundation Fellowship in Painting.

TOMATA DU PLENTY Exhibitions/Performances: 1987, Bad Eye Gallery; 1987, dance debut in "Last Stop L.A." at L.A.C.E.; 1987, directed and designed sets for "Compulsive Cabaret," Museum of Contemporary Art, Los Angeles, CA.; 1986, "Whores, Sluts and Tramps," Cheap Racist Gallery, Los Angeles, CA.; 1983, Zero One Gallery, Hollywood, CA.; 1976-80, created and performed as lead singer in the Screamers musical group, Los Angeles, CA.; 1972-1974, joined Gorilla Rose in comic collaborations, worked with Blondie and the Ramones at C.B.G.B.'s, appeared in off-off Broadway revues: "The Palm Casino" and "The Roseland Revue," directed by Tommy Tune, New York, NY.; 1969-72, formed own theater group, "Ze Whiz Kidz," (created and performed more than a hundred comedy/musical shows with group), Seattle, WA.

CLAIRE FALKENSTEIN Exhibitions: 1987, 1978, Guggenheim Museum, New York, NY.; 1986, 1984, Jack Rutberg Fine Arts, Los Angeles, CA.; 1985, Smithsonian Institution, Washington, D.C.; 1978, Tate Gallery, London, England; 1968, Victoria & Albert Museum, London, England; 1964, 1960, Whitney Museum of American Art, New York, NY.; 1963, 1960, Martha Jackson Gallery, New York, NY.; 1962, Musee des Arts Decoratifs, Palais de Louvre, Paris, France; 1961, Musee Rodin, Paris, France; 1948, 1942, San Francisco Museum of Art, San Francisco, CA. Commissions: 1987, FORUM, outdoor installation tribute to A. Quincy Jones, California State Univ., Dominguez Hills, CA.; 1962 FIRE SCREEN, Baron Alix de Rothschild, Normandy, France (exhibited at Louvre); 1961, Garden Gates for Guggenheim Museum, Venice, Italy.

SAM FRANCIS Exhibitions: 1986-87, 1981-1984, 1975-1977, 1969-1972, Andre Emmerich Gallery, New York, NY.; 1985-86, 1979, 1975-1977, Galerie Jean Fournier, Paris, France; 1985-86, 1982, Nantenshi Gallery, Tokyo, Japan. 1983, Travelling survey of works on paper through the Art Museum Association of America; 1979, Retrospective exhibition of works on paper at Institute of Contemporary Art, Boston, MA. (travelled to Taiwan, Hong Kong, Manila, Korea, and Japan under the U.S. International Communication Agency; 1972, Retrospective exhibition at the Albright-Knox Art Gallery, Buffalo, NY. (travelled to Corcoran Gallery, Washington, D.C.; Whitney Museum of American Art, New York, NY., Dallas Museum of Fine Arts, Dallas, TX., Oakland Museum, Oakland, CA.); 1968, Exhibition at Centre Nationale d'Art Contemporain, Paris and Kunsthalle, Basel, Switzerland. Commissions: 1986, Mural for ceiling of Opera National, Theatre Royal de la Monnaie, Brussels, Belgium; 1985, Mural for San Francisco Museum of Art, San Francisco, CA.; 1983, San Francisco Airport Mural; 1969-71, Mural for National Gallery of Art, Berlin, West Germany (painted and installed).

CURT FRIEDRICHS Exhibitions, Solo: 1986, Carr & Associates. Group: 1987, California International Arts Foundation, Los Angeles, CA.; Valerie Miller & Assoc., Los Angeles, CA.; 1986, Karl Bornstein Gallery, Santa Monica, CA.; 1985, Terry DeLapp Gallery, Los Angeles, CA.

MARK GASH Exhibitions, Solo: 1985, "The Scarecrow's Journey," Attack Gallery, Los Angeles, CA.; 1984, "Zero One Portraits," Zero One Gallery, Hollywood, CA.; 1981, California Institute of the Arts, Valencia, CA. Group: 1985, "Attack Group Show," Piezo Electric, New York, NY.; Exploratorium Gallery, California State Univ., Los Angeles, CA.; 1984, Attack Gallery, Los Angeles, CA.; "L.A. Cartoonist Artist Show," P.S. 1, Long Island City, NY.

CANDICE GAWNE Exhibitions, Solo: 1987, Museum of Neon Art, Los Angeles, CA.; 1985, Laguna Beach Museum of Art, Laguna Beach, CA.; 1983/85, Karl Bornstein Gallery, Santa Monica, CA. Group: 1987, "L.A. Today: Contemporary Vision," Amerika Haus, Berlin, West Germany and Municipal Art Gallery, Los Angeles, CA.; 1987, "American Pop Culture Images Today," Laforet Museum, Tokyo, Japan; 1985, Frederick Weisman Traveling Collection, Washington, D.C. and Israel Museum, Jerusalem, Israel; 1985, "Spectrum Los Angeles," Gallerie Akmak, Berlin, and Hartje Gallery, Frankfurt, West Germany; 1985, "Sunshine and Shadow: Recent Painting in Southern California," Fisher Gallery, Univ. of Southern California, Los Angeles, CA.; 1985, "New Directions/California Painting 1985," Visual Arts Center of Alaska, Anchorage, AK.; 1982, "Magical Mystery Tour," Municipal Art Gallery, Los Angeles, CA.

JILL GIEGERICH Exhibitions, Solo: 1987, 1985, 1983, Margo Leavin Gallery, Los Angeles, CA; 1986, David McKee Gallery, New York, NY.; 1985, "Summer 1985: Nine Artists," Museum of Contemporary Art, Los Angeles, CA.; 1981, Riko Mizuno Gallery, Los Angeles, CA. Group: 1987, "Toyama Now '87: New Art

Around the Pacific," Museum of Modern Art, Toyama, Japan; 1985, "Biennial Exhibition," Whitney Museum of American Art, New York, NY.; 1983, "LA-NY Exchange," Artists Space, New York, NY. *Awards/Grants:* 1986, Awards in the Visual Arts; 1984, National Endowment of the Arts Grant.

GRONK *Exhibitions, Solo:* 1986-87, Saxon-Lee Gallery, Los Angeles, CA.; 1985, "The Titanic and Other Tragedies at Sea," Galeria Ocaso, Los Angeles, CA.; 1984, "Gronk," Molly Barnes Gallery, Los Angeles, CA. *Group:* 1987, "On the Wall," Santa Barbara Contemporary Arts Forum, Santa Barbara, CA.; 1987-89, "5 Artists/5 Installations," Santa Barbara Contemporary Arts Forum, Santa Barbara, CA. (catalog); 1987-89, "Contemporary Hispanic Art in the United States," Houston Museum of Fine Arts, Houston, TX. (also Corcoran Gallery of Art, Washington, D.C., Brooklyn Museum, New York, NY.); 1985, "Summer 1985," Museum of Contemporary Art, Los Angeles, CA. (catalog); 1984, "Asco '84," Armory for the Arts, Santa Fe, NM. *Awards/Grants:* 1983, Visual Artist Fellowship, National Endowment for the Arts.

STEVE GROSSMAN *Exhibitions, Solo:* 1987, 1985, 1983, Jan Baum Gallery, Los Angeles, CA.; 1982, Los Angeles County Museum of Art Rental Gallery, Los Angeles, CA.; 1981, Los Angeles Contemporary Exhibitions, Los Angeles, CA. *Group:* 1987, Ammo Gallery, Brooklyn, NY.; 1986, 1984, 1983, Jan Baum Gallery, Los Angeles, CA.; 1983, 1982, 1981, 1979, Municipal Art Gallery, Los Angeles, CA.

D. J. HALL *Exhibitions, Solo:* 1986, "D. J. Hall: 1974-1985," Municipal Art Gallery, Los Angeles, CA.; 1985, O. K. Harris Works of Art, New York, NY. *Group:* 1987, Amerika Haus, Berlin, West Germany; 1987, "Sense of Place," Art Galleries, Univ. of Southern California, Los Angeles, CA.; 1983, "Faces Since the 50's: A Generation of American Portraiture," Center Gallery, Bushnell Univ., Lewisberg, PA. (catalog); "A Heritage Renewed," Art Museum, Univ. of California, Santa Barbara, CA. (traveled to Oklahoma Art Center, Oklahoma City, OK.; Elvehjem Museum of Art, Madison, WI.; Colorado Springs Fine Arts Center, Colorado Springs, CO.-catalog); 1982, "New Directions: Contem-

porary American Art from The Commodities Corporation," Princeton, NJ. (traveled to the Museum of Art, Fort Lauderdale, FL.; Oklahoma Museum of Art, Oklahoma City, OK.; Santa Barbara Museum of Art, Santa Barbara, CA.; Grand Rapids Art Museum, Grand Rapids, MI.; Madison Art Center, Madison, WI.; Montgomery Museum of Fine Arts, Montgomery, AL.-catalog); 1981, "Changes: Art in America 1881/1981," Marquette University, Milwaukee, WI. (catalog); 1981, "New Dimensions in Drawing," Aldrich Museum, Ridgefield, CT.; 1981, "Contemporary American Realism Since 1960," Pennsylvania Academy of Fine Arts, Philadelphia, PA., (traveled to Virginia Museum of Art, Richmond, VA.; Oakland Museum, Oakland, CA.; Gulbenkian Museum, Lisbon, Portugal; Salas de Exposiciones de Belles Artes, Madrid, Spain; Kunsthalle, Nuremberg, West Germany-catalog).

LLOYD HAMROL *Exhibitions:* 1986, Exhibition and Installation, Municipal Art Gallery, Los Angeles, CA.; 1985, "The Artist as Social Designer," Los Angeles County Museum of Art, Los Angeles, CA.; 1983, "Young Talent Awards: 1963-1983," Los Angeles County Museum of Art, Los Angeles, CA.; 1981, "The Museum as Site: Sixteen Projects," Los Angeles County Museum of Art, Los Angeles, CA.; 1980, "Across the Nation: Fine Art for Federal Buildings, 1972-79," National Collection of Fine Arts, Smithsonian Institution, Washington, D.C. (also, Hunter Museum of Art, Chattanooga, Tennessee. *Site Projects:* 1986, "Uptown Rocker," 4th and Lower Grand, Los Angeles, CA.; 1985, "Twenty-One Stones," Exposition Park, Los Angeles, CA.; 1984, "Coral Square," Broward Community College, Pembroke Pines, FL.; 1983, "City Terrace," Civic Center, Anaheim, CA.; 1980, "Highground," School of Law, Univ. of New Mexico, Albuquerque, NM.

MADDEN HARKNESS *Exhibitions, Solo:* 1987, Ivory Kimpton, San Francisco, CA.; 1987, Roy Boyd, Santa Monica, CA.; 1985, The Slant Gallery, Sacramento, CA. *Group:* 1987, "Newcomers '87," Municipal Art Gallery, Los Angeles, CA.; "Contemporary Southern California," Taipei Fine Arts Museum, Taipei, Taiwan, R.O.C.; 1986, "Extraordinary Perceptions," Los Angeles

County Museum of Art Rental Gallery, Los Angeles, CA.; "Black and White Images," (two person show), The Women's Bldg., Los Angeles, CA.; 1985, Drawing National, Everson Museum of Art, Syracuse, NY. (purchase award); 1983-84, Crocker-Kingsley Exhibition, Crocker Art Museum, Sacramento, CA.; 1981, "Small Works," 80 Washington Square East Galleries, New York, NY.

JAMES HAYWARD *Exhibitions, Solo:* 1986, Rosamund Felsen Gallery, Los Angeles, CA.; 1980-84, Modernism, San Francisco, CA.; 1980-83, Mizuno Gallery, Los Angeles, CA.; 1979, Sidney Janis, New York, NY.; *Group:* 1984, "The 59th Anniversary Show," Museum of Modern Art, San Francisco, CA.; 1983, "Young Talent Awards: 1963-1983," Los Angeles County Museum of Art, Los Angeles, CA.; 1982, "Contemporary Los Angeles Painters," Nagoya City Museum, Nagoya, Japan (traveled to Municipal Art Gallery, Los Angeles, CA.); 1977, "Less is More," and "Hayward-Miller," Sidney Janis Gallery, New York, NY. *Awards/Grants:* 1983-84, John Simon Guggenheim Fellowship (painting); 1977, Young Talent Award, Los Angeles County Museum of Art, Los Angeles, CA.

ROGER HERMAN *Exhibitions, Solo:* 1987-88, Ace Gallery, Los Angeles, CA.; 1984, Hal Bromm Gallery, New York, NY.; 1983, La Jolla Museum of Contemporary Art, La Jolla, CA.; 1982, Akademie der Kunst, Karlsruhe, West Germany; 1982, 1981, Ullrike Kantor Gallery, Los Angeles, CA.; 1982, Art Institute, San Francisco, CA. *Group:* 1987, Avant Garde of the 80's, Los Angeles County Museum of Art, Los Angeles, CA.; 1985, Institute for Contemporary Art, Philadelphia, PA.; 1984, 1982, Museum of Modern Art, San Francisco, CA.; 1984, Walker Art Museum, Minneapolis, MN.; 1983, Los Angeles County Museum of Art, "New Talent Award," Los Angeles, CA.

GEORGE HERMS *Exhibitions, Solo:* 1987, "Monument to Unknown-Clocktower," MacArthur Park, Los Angeles, CA.; "Rome Poem Revisited," Temple Univ., Philadelphia, PA.; 1986, L.A. Louver, Los Angeles, CA.; 1984, "George Herms: Rome Poem," Art Gallery, California State Univ., Fullerton, CA. (catalog); 1979, "The

Prometheus Archives: A Retrospective Exhibition of the Works of George Herms," Newport Harbor Art Museum, Newport Beach, CA. (travelled to Oakland Museum, Oakland, CA., Seattle Art Museum, Seattle, WA., catalog). 1961, Batman Gallery, San Francisco, CA.; *Group:* 1986-87, "Individuals: A Selected History of Contemporary Art," Museum of Contemporary Art, Los Angeles, CA. (catalog); 1976-77, "Painting and Sculpture in California: The Modern Era," Museum of Modern Art, San Francisco, CA. (travelled to The National Collection of Fine Arts, Smithsonian Institution, Washington, D.C.-catalog); 1974, "Word Works," Mount San Antonio College, Walnut, CA.; 1974, "Poets of the Cities New York and San Francisco 1950-1965," Dallas Museum of Fine Arts, Dallas, TX. (travelled to San Francisco Museum of Art, San Francisco, CA.; Wadsworth Atheneum, Hartford, CT.-catalog), 1974, Univ. of Nevada, Las Vegas, NV.; 1961, "The Art of Assemblage," Museum of Modern Art, New York, NY. (travelled to Dallas Museum of Contemporary Art, Dallas, TX.; San Francisco Museum of Art, San Francisco, CA.-catalog). *Awards/Grants:* 1984, National Endowment for the Arts, Individual Fellowship; 1983-84, John Simon Guggenheim Fellowship in Sculpture; 1982-83, Prix de Rome, Fellowship in Sculpture, American Academy in Rome.

PETER HESS *Exhibitions, Solo:* 1985-1987, Koplin Gallery, Los Angeles, CA.; 1984, Municipal Art Gallery, Los Angeles, CA.; 1983, Art Gallery, Biola Univ., La Mirada, CA. *Group:* 1986, "Uncovering the Past: Tribute and Parody," Long Beach Museum of Art, Long Beach, CA. (catalog); "Miracles and Mysteries," California State Univ. Dominguez Hills, Carson, CA.; 1985, "Yard Art," Laguna Beach Museum of Art, Laguna Beach, CA.; 1984, "Cultural Excavations," One Market Plaza, San Francisco, CA.; "California Bookworks: The Last Five Years," Otis Art Institute of Parsons School of Design, Los Angeles, CA. (catalog); 1983, "Show III," Los Angeles County Museum of Art Rental Gallery, Los Angeles, CA.; 1982, "Small Images 6," Atkinson Art Gallery, Santa Barbara City College, Santa Barbara, CA. (catalog).

DAVID HOCKNEY *Exhibitions, Solo:* 1988-89, Major Retrospective, L.A. Co. Mus. of Art, L.A., CA. (travels to Metro. Mus. of Art, New York, NY. and Tate Gallery, London, Eng.); 1986-87, Loyola Univ., L.A., CA. (also catalog); 1986-87, Set and costume design for *Tristan und Isolde*, L.A. Opera Co., L.A., CA.; 1985, Cover and 40 pages, Dec.issue, French *Vogue* magazine; 1984-85, 1978-80, "Lithographs," Tyler Graphics, Bedford Village, NY.; 1975-1983, Set and costume design for operas: *The Rake's Progress, The Magic Flute, Parade, Les Mamelles de Tiresias, L'Enfant et les Sortileges, Le Sacre du Printemps, Le Rossignol, Oedipus Rex, Paid on Both Sides*; 1983, Set design for ballet, *Varii Capricci*, Royal Ballet Co. (performed in New York, NY.). *Awards:* 1985, First Prize, Intl. Center of Photography, New York, NY.; 1985, Honorary Degree, San Francisco Art Inst., San Francisco, CA.; 1985, Honorary Doctorate in Fine Art, Otis Art Inst., L.A., CA.; 1983, German Award of Excellence; 1964, First Prize, 8th Intl. Exhibition of Drawings and Engravings, Lugano, Italy; 1963, Graphics Prize, Paris Biennale, Paris, France.

ROBERT IRWIN *Exhibitions & Etc.:* 1987, Arts Enrichment Master Plan, Miami International Airport, Miami, FL.; 1986, Central Avenue Median, Museum of Contemporary Art, Los Angeles, CA.; 1985, Museum of Modern Art, San Francisco, CA.; 1985, 1974, 1963-73, Pace Gallery, New York; 1983, Two Ceremonial Gates: Pacific Asian Basin, S.F. International Airport, San Francisco, CA.; 1980-81, 1971, 1966, 1960, 1956, 1952-53, Los Angeles County Museum of Art, Los Angeles, CA; 1980, Aspects of the 70's, Siteworks, Wellesley College, Wellesley, MA.; 1979, "Robert Irwin: Untitled Installation" (3 Triangulated Light Planes), Univ. Art Museum, Univ. of California, Berkeley, CA.; "Painting In Environment," Palazzo Real, Comune di Milano, Italy; Seattle Arts Commission, Public Safety Bldg., North Plaza, Seattle, WA.; 1978, N.E.A. Art in Public Places Project, Dallas, TX.; 1977, "Robert Irwin" (retrospective of early work), Whitney Museum of American Art, New York, NY.; 1976, 37th Venice Biennale, Venice, Italy; 1975, "Robert Irwin: Continuing Responses," Fort Worth Art Museum, Fort Worth, TX.; 1958-65, Ferus Gallery, Los Angeles, CA.

JIM ISERMANN *Exhibitions, Solo:* 1986, "Flowers", Patty Aande Gallery, San Diego, CA.; 1982-1986, Kuhlenschmidt/Simon Gallery, Los Angeles, CA.; 1982, "Patio Tempo", Artists Space, New York, NY. *Permanent Installations:* 1986, "T.V. Room," Video screening lounge, L.A.C.E., Los Angeles, CA. *Group:* 1986, "California Chairs," Aspen Art Museum, Aspen, CO.; 1985, "Future Furniture," Newport Harbor Art Museum, Newport Beach, CA.; 1984, "Furniture, Furnishings: Subject and Object," Museum of Art, Rhode Island School of Design (traveling exhibition through 1985). *Awards/Grants:* 1984, NEA Visual Artists Fellowship, Sculpture.

CONNIE JENKINS *Exhibitions, Solo:* 1988, 1985, 1984, 1982, Koplin Gallery, Los Angeles, CA. *Group:* 1987, "Passages: A Survey of California Women Artists, 1945 to Present," Fresno Arts Center and Museum, Fresno, CA.; 1986, "Through the Eyes of an Artist," Laband Gallery, Loyola Marymount Univ., Los Angeles, CA.; 1984, "Sun and Surf," One Market Street, San Francisco, CA. (also, Transamerica Center Gallery, Los Angeles, CA.); 1983, "West Coast Realism," Laguna Beach Museum of Art, Laguna Beach, CA. (also, Museum of Art, Fort Lauderdale, FL.); 1982, "The Real Thing: Southern California Realist Painting," Laguna Beach Museum of Art, Laguna Beach, CA.; 1980, "L.A. Artists Look at L.A.," Municipal Art Gallery, Los Angeles, CA.; 1978, "California Realist Painters," Nevada Fine Arts Gallery, Reno, NV.

TOM JENKINS *Exhibitions, Solo:* 1987, Forum International, Zurich, Switzerland; 1983-86, Karl Bornstein Gallery, Santa Monica, CA.; 1982, Espace DBD, Los Angeles, CA.; 1981, Baxter Art Gallery, California Institute of Technology, Pasadena, CA. *Group:* 1985, "Spectrum Los Angeles," Hartje Gallery, Berlin, West Germany; "New Directions/California Painting 1985," Visual Arts Center, Anchorage, AK.; "To the Astonishing Horizon," Design Center, Los Angeles, CA.; 1984, "A Broad Spectrum: '84 Olympics Art Festival, Design Center, Los Angeles, CA.; 1981, "More Than One Sense," Los Angeles County Art Museum, Los Angeles, CA.; 1981, Performance Art, Tortue Gallery, Santa Monica, CA.

MIKE KELLEY *Exhibitions, Solo:* 1983-87, Rosamund Felsen Gallery, Los Angeles, CA.; 1984-86, Metro Pictures, New York, NY.; 1983, Hall Walls, Buffalo, NY.; 1981, Mizuno Gallery, Los Angeles, CA. *Group:* 1987, "Avant Garde in the Eighties," Los Angeles County Museum of Art, Los Angeles, CA. (catalog); "Toyama Now '87," Museum of Modern Art, Toyama, Japan (catalog; "1987 Phoenix Biennial," Art Museum, Phoenix, Arizona; 1986, "Individuals: A Selected History of Contemporary Art, 1945-1986," Museum of Contemporary Art, Los Angeles (catalog); 1985, "1985 Biennial Exhibition," Whitney Museum of American Art, New York, NY. (catalog); 1983, Museum of Contemporary Art, Los Angeles, CA.

RANDALL LAVENDER *Exhibitions, Solo:* 1987, Jan Turner Gallery, Inc., Los Angeles, CA.; 1984, Art Gallery, Santa Monica College, Santa Monica, CA.; 1983, Conflicting Ideals, Fine Arts Center at Cheekwood, Nashville, TN.; *Group:* 1986, The Frederick R. Weisman Foundation Collection, Kalouste Gulbenkian Museum, Lisbon, Portugal; 1985, Randall Lavender/John Frame, Fellows Gallery, Denison Univ., Granville, OH.; *Collections:* The Frederick R. Weisman Foundation, Los Angeles, CA.; Vanderbilt Univ., Nashville, TN.; Marvin & Judy Zeidler, Los Angeles, CA.; Ann & Bill Harmsen, Santa Monica, CA.; Pamela Leeds, Los Angeles, CA.

MARK ALLEN LERE *Exhibitions, Solo:* 1986, Carnegie-Mellon Univ., Pittsburgh, PA. (catalog); 1985, "New and Selected Work, "Museum of Contemporary Art, Los Angeles, CA. (catalog); 1984-1987, Margo Leavin Gallery, Los Angeles, CA.; 1983, Riko Mizuno Gallery, Los Angeles, CA. *Group:* 1987, Los Angeles County Museum of Art; 1987, Taipei Fine Arts Museum, Taipei, Taiwan, R.O.C.; 1987, Museum of Contemporary Art, Los Angeles, CA.; 1986, John Berggruen Gallery, San Francisco, CA.; 1986, Frankfurt Kunstverein, Frankfurt, West Germany; 1986, American Academy and Institute of Arts and Letters, New York, NY.; 1985, Galeria Communale d'arte Moderna, Bologna, Italy; 1984, Venice Biennale, Venice, Italy.

HELEN LUNDEBERG *Exhibitions, Solo:* 1987, "Helen Lundeberg: California Contemporary," Laguna Art Museum, Laguna Beach, CA.; 1985, "Helen Lundeberg: Still Life," Tobey C. Moss Gallery, Los Angeles, CA.; 1983, "Helen Lundeberg Since 1970," Desert Museum, Palm Springs, CA.; 1979, "Retrospective," Municipal Art Gallery, Los Angeles, CA.; 1971, "Retrospective," La Jolla Museum of Contemporary Art, La Jolla, CA.; 1953, One person retrospective, Pasadena Art Institute, Pasadena, CA. *Group:* 1980-81, joint retrospective with Lorser Feitelson, Museum of Modern Art, San Francisco, CA. (travelled to Frederick S. Wight Gallery, Univ. of California, Los Angeles, CA.); 1962, Included in "Geometric Abstraction in America," Whitney Museum of American Art, New York NY.; 1942, "Americans 1942/18 Artists from 9 States," Museum of Modern Art, New York, NY.; 1936, "Fantastic Art, Dada, Surrealism," Museum of Modern Art, New York, NY.

CONSTANCE MALLINSON *Exhibitions:* 1981-1985, Ovsey Gallery, Los Angeles, CA.; 1985, "Artpark Artists," Buscaglia Castellani Gallery, Niagara, NY.; 1984, 1981, Los Angeles County Museum of Art Rental Gallery, Los Angeles, CA.; 1983, "Landscape," Sander Chrichton Gallery, Seattle, WA.; 1983, "Attention California," The Oakland Museum, Oakland, CA.; 1982, "Ten From Los Angeles," Dongsangbang Gallery, Seoul, Korea; 1973-1977, "New Work, Gallery Artists," Henri Gallery, Washington, D.C.; 1976, Washington Women's Art Center, Washington, D.C. *Awards/Grants:* National Endowment for the Arts, $15,000 Artist Fellowship.

JOHN McCRACKEN *Exhibitions, Solo:* 1986-87, P.S. 1, Long Island City, NY. (travelled to Newport Harbor Art Museum, Newport Beach, CA.); 1985, Ace Gallery, Los Angeles, CA.; 1972-73, 1966, 1968, Robert Elkon Gallery, New York, NY.; 1970, Sonnabend Gallery, New York, NY.; 1969, Art Gallery of Ontario, Toronto, ON.; Galerie Ileana Sonnabend, Paris, France; 1968, 1967, 1965, Nicholas Wilder Gallery, Los Angeles, CA. *Group:* 1986, "Venice Biennale," Venice, Italy. *Collections:* Museum of Modern Art, New York, NY.; Guggenheim Museum, New York, NY.; Whitney Museum of American Art, New York, NY.

MICHAEL McMILLEN *Exhibitions, Solo:* 1987, "Michael McMillen/Red Grooms," Municipal Art Gallery, Los Angeles, CA.; 1987, "The Pavilion of Rain," California State Univ. Art Gallery, Northridge, CA.; 1978, "Inner City," Whitney Museum of American Art, New York, NY. *Group:* 1987, "Emerging Artists 1978-1986: Selections from the Exxon Series," Guggenheim Museum, New York, NY.; 1987, "Contemporary Southern Californian Art," Taipei Fine Arts Museum, Taipei, Taiwan, R.O.C.; 1983, "New Perspectives in American Art – 1983 Exxon National Exhibition," Guggenheim Museum, New York, NY.; 1983, "The Second Western States Exhibition and the 38th Corcoran Biennial Exhibition of American Painting," Corcoran Gallery of Art, Washington, D.C.; 1981; "Art in Los Angeles – The Museum as Site: Sixteen Projects," Los Angeles County Museum of Art, Los Angeles, CA.; 1979, "Eight Artists: The Elusive Image," The Walker Art Center, Minneapolis, MN.; 1977, "Los Angeles In The Seventies," Fort Worth Art Museum, Fort Worth, TX.; 1976, Biennale of Sydney – November 1976, Art Gallery of New South Wales, Sydney, Australia.

JIM MORPHESIS *Exhibitions, Solo:* 1987, 1986, 1984, 1983, Tortue Gallery, Santa Monica, CA.; 1987, 1986, Acme Art, San Francisco, CA.; 1987, Marianne Deson Gallery, Chicago, IL.; 1983, Freidus/Ordover Gallery, New York, NY. *Group:* 1987, "Avant-Garde in the Eighties," Los Angeles County Museum of Art, Los Angeles, CA.; 1987, "Abstract Expressionism and After," Museum of Modern Art, San Francisco, CA.; 1986, "Ancient Currents," Fisher Gallery, Univ. of Southern California, Los Angeles, CA.; 1985, "California Paintings and Sculpture from the collection of the Capital Group," Security Pacific National Bank's Gallery at The Plaza, Los Angeles, CA.; 1985, "Concerning The Spiritual: The Eighties," Emanuel Walker/Atholl McBean Galleries, San Francisco Art Institute, San Francisco, CA.; 1983, Young Talent Awards 1963-1983, Los Angeles County Museum of Art, Los Angeles, CA.

ED MOSES *Exhibitions, Solo:* 1985-1987, L.A. Louver Gallery, Venice, CA.; 1981-82, Janus Gallery, Los Angeles, CA.; 1979-1981, James Corcoran Gallery, Los Angeles, CA.; 1980, High Museum of Art, Atlanta, GA. (commissioned wall painting, entrance to museum); 1976, Los Angeles County Museum of Art, Los Angeles, CA.; 1974-75, Andre Emmerich Gallery, New York, NY.; 1973-74, Art in Progress Gallery, Munich, Germany (also Zurich and Basel, Switzerland. *Group:* National Gallery of Art, Washington, D.C.; Museum of Contemporary Art, Los Angeles, CA.; Nagoya City Museum, Nagoya, Japan; Museum of Modern Art, Paris, France; Museum of Modern Art, Lodz, Poland; Corcoran Gallery of Art, Washington, D.C.; Museum of Modern Art, New York, NY. *Collections:* Corcoran Gallery of Art, Washington, D.C.; Hirshhorn Museum, Washington, D.C.; Los Angeles County Museum of Art, Los Angeles, CA.; Museum of Modern Art, New York, NY.; Whitney Museum of American Art, New York, NY.

GWYNN MURRILL *Exhibition, Solo:* 1985-1987, Asher/Faure Gallery, Los Angeles, CA.; 1985-1987, John Berggruen Gallery, San Francisco, CA.; 1977, Nicholas Wilder Gallery, Los Angeles, CA. *Group:* 1983, "Young Talent Award: 1963-1983," Los Angeles County Museum of Art, Los Angeles, CA.; 1982, "Contemporary Californians VIII," Laguna Beach Museum of Art, Laguna Beach, CA. *Awards/Grants:* 1986, John Simon Guggenheim Fellowship; 1984-85, National Endowment Individual Artist Grant; 1979-80, Prix Di Roma Fellowship, American Academy, Rome, Italy; 1978, New Talent Purchase Award, Los Angeles County Museum of Art, Los Angeles, CA.

GIFFORD CHANDLER MYERS *Exhibitions, Solo:* 1988, Los Angeles County Museum of Art, Los Angeles, CA.; 1986, 1984, John Berggruen Gallery, San Francisco, CA.; 1985, University Art Museum, Berkeley, CA.; 1985, Laguna Beach Museum of Art, Laguna Beach, CA.; 1985, Art Museum, Univ. of California, Santa Barbara, CA.; 1982, Municipal Art Gallery, Los Angeles, CA.; 1982, McIntosh/Drysdale Gallery, Washington, D.C.; 1981, Janus Gallery, Los Angeles, CA. *Group:* 1984, "Young Talent Award," Los Angeles County Museum of Art, Los Angeles, CA. *Awards/Grants:* 1979, Fellowship, National Endowment for the Arts.

VICTORIA NODIFF *Exhibitions, Solo:* 1988, Robert Berman Gallery, Venice, CA.; 1987, Littlejohn-Smith Gallery, New York, NY.; 1983, Koplin Gallery, Los Angeles, CA.; 1981, Rubicon Gallery, Palo Alto, CA. *Group:* 1987, "Animals," Visual Arts Center, California State Univ., Fullerton, CA.; 1986, "Dog Days of August," Littlejohn-Smith Gallery, New York, NY.; 1986, "Heart Fetishes," B-1 Gallery, Santa Monica, CA.; 1986, "Let's Play House," Bernice Steinbaum Gallery, New York, NY.; 1986, 22nd Biennial Exhibition," Univ. of Delaware, Newark, DE. (purchase award); 1983-84, Group Shows, Koplin Gallery, Los Angeles, CA.

BAILE OAKES *Exhibitions:* 1989, "Gestation III," Palisades Park, Santa Monica, CA.; 1988, "Gestation," World Expo '88, Brisbane, Australia; 1988, "Environmental Sculpture," California Arts Council Comm., Gaviota State Park, Gaviota, CA.; 1987, Design Commission, "Inspiration Point," Newport Arts Commission, Newport Beach, CA.; 1986 "Spiral of Life II," Sculpture Garden, Long Beach Museum of Art, Long Beach, CA.; 1984, Wood Renditions, Group Show, Security Pacific Plaza, Los Angeles, CA.; 1983, Designed and constructed the Playground, Mission YMCA, San Francisco, CA.; 1976-78, Artist in Residence, Art Park, Lewiston, NY. *Awards/Grants:* 1982-83, Recipient of National Endowment for the Arts Grant.

ERIC ORR *Exhibitions, Solo:* 1987, Georges Lavrov Gallery, Paris, France; 1986, James Corcoran Gallery, Los Angeles, CA.; 1985, Works Gallery, Long Beach, CA.; 1985, Gemeentemuseum, Den Haag, Netherlands; 1984, San Diego State Univ., San Diego, CA.; 1983, Ovsey Gallery, Los Angeles, CA.; 1980, Los Angeles County Museum of Art, Los Angeles, CA.; 1978, Cirrus Gallery, Los Angeles, CA.; 1978, Delahunty Gallery, Dallas, TX.; 1975, Salvatore Ala Gallery, Los Angeles, CA.

ANN PAGE *Exhibitions, Solo:* 1986, 1982, 1981, 1979, 1977, 1976, Space Gallery, Los Angeles, CA.; 1986, Art Gallery, Pepperdine Univ., Malibu, CA.; 1985, Municipal Art Gallery, Los Angeles, CA.; 1984, Focus Gallery, Honolulu Academy of Arts, Honolulu, HI.; 1984, Caroline Lee Gallery, San Antonio, TX.; 1980, Cantor/Lemberg Gallery, Birmingham, MI. *Group:* 1986, "Expressions in Paper," Security Pacific Plaza, Los Angeles, CA.; 1985, "Selections," Contemporary Art Center, Honolulu, HI.; 1984, "Traditions Transformed," Oakland Museum, Oakland, CA.; 1979, "Abstractions/ Sources/Transformations," Municipal Art Gallery, Los Angeles, CA.

LAURIE PINCUS *Exhibitions, Solo:* 1987, California Contemporary Artists Series #35, Laguna Beach Art Museum, Laguna Beach, CA.; 1987, Allrich Gallery, San Francisco, CA.; 1986, "Sleepwalkers, Gangsters and the Junior League," Jan Baum Gallery, Los Angeles, CA.; 1986, Galleria Grafica Tokio, Tokyo, Japan; 1984, 1981, Jan Baum Gallery, Los Angeles, CA.; 1983, Dobrick Gallery, Chicago, IL. *Group:* 1987, "On The Horizon: Emerging in California," Fresno Arts Center and Museum, Fresno, CA.; 1985, "Los Angeles Painters on the Edge," Quay Gallery, San Francisco, CA.; 1981, Invitational, "New in New York," Monique Knowlton Gallery, New York, NY.

JACK REILLY *Exhibitions, Solo:* 1987, California State Univ., Northridge, CA.; 1986, Mission Gallery, New York, NY.; 1985, Stella Polaris Gallery, Los Angeles, CA.; 1984, Long Beach City College, Long Beach, CA.; 1983, Foster Goldstrom Fine Arts, San Francisco, CA.; 1983, Academy of Art College, San Francisco, CA.; 1981, Aaron Berman Gallery, New York, NY., 1981, Molly Barnes Gallery, Los Angeles, CA.; 1981, Matthews Center Museum, Arizona State Univ., Tempe, AZ.; 1981, Marilyn Butler Gallery, Scottsdale, AZ.

ROLAND REISS *Exhibitions, Solo:* 1987, 1986, 1984, 1983, 1980, Flow Ace Gallery, Los Angeles, CA.; 1977, Los Angeles County Museum of Art, Los Angeles, CA. *Group:* 1987, "Avant-Garde in the Eighties," Los Angeles County Museum of Art, Los Angeles, CA.; 1987, "California Figurative Sculpture," Desert Museum, Palm Springs, CA.; 1985, "Boxes," Museo Tamayo, Mexico City, Mexico; 1982, "documenta 7," Kassel, Germany; 1979, "Directions," Hirshhorn Museum, Washington, D.C.; 1976, "Painting and Sculpture in California: The Modern Era," Museum of Art, San Francisco, CA. (also National Collection of Fine Arts, The Smithso-

nian Institution, Washington, D.C.); 1975, Whitney Biennial Exhibition, New York, NY. *Awards/Grants:* NEA Visual Artists Fellowship, Sculpture; 1986-87, 1979-80, 1976-77, 1970-71.

LEO ROBINSON *Exhibitions, Solo:* 1986, El Camino College Art Gallery, Torrance, CA.; 1985, Simard/Halm Gallery, Los Angeles, CA.; 1984, Santa Monica College, Santa Monica, CA.; 1981, Orlando Gallery, Sherman Oaks, CA. *Group:* 1987, "Relationships, Eileen Cowin, Dan McCleary, Leo Robinson, Joyce Treiman," Long Beach Museum of Art, Long Beach, CA.; 1987, "Contemporary Southern California Art," Taipei Fine Arts Museum, Taipei, Taiwan, R.O.C.; 1985, "The Spiritual Eye: Religious Imagery in Contemporary Los Angeles Art," Loyola Law School, Los Angeles, CA.

FRANK ROMERO *Exhibitions, Solo:* 1987, Robert Berman Gallery, Los Angeles, CA.; 1986, "Frank Romero New Work," Karl Bornstein Gallery, Santa Monica, CA.; 1984, New Clay Work, Koplin Gallery, Los Angeles, CA.; 1984, "Frank Romero," Simard Gallery, Los Angeles, CA.; 1984, "Paintings, Drawings and Clay, 1974-84," Arco Center for Visual Art, Los Angeles, CA.; 1981-82, "Frank Romero Paintings and Drawings," Oranges and Sardines Gallery, Los Angeles, CA. *Group:* 1987, "Hispanic Art in the United States," Museum of Fine Arts, Houston, TX. (travelled to Corcoran Gallery of Art, Washington, D.C., Brooklyn Museum, Brooklyn, NY., Denver Art Museum, Denver CO., Los Angeles County Museum of Art, Los Angeles, CA., also, Mexico City, Mexico); 1985, "Spectrum Los Angeles: neue Kunst aus Californien," Hartje Gallery, Frankfurt, Germany, and tour; 1982, Magical Mystery Tour, Municipal Art Gallery, Los Angeles, CA.; 1978, "The Aesthetics of Graffiti," Museum of Modern Art, San Francisco, CA.; 1977-78, "Ancient Roots/New Visions," Art Museum, Tucson, AZ. (and tour).

SANDRA MENDELSOHN RUBIN *Exhibitions, Solo:* 1987, Claude Bernard Gallery, New York, NY. (catalog); 1985, "Gallery 6: Sandra Mendelsohn Rubin, 1980-1985," (illustrated brochure), Los Angeles County Museum of Art, Los Angeles,

CA.; 1985, Fischer Fine Arts, London, England (catalog); 1982, "Selected Paintings and Drawings from 1980-1982," L. A. Louver, Venice, CA. *Group:* 1983, "Young Talent Awards: 1963-1983," Los Angeles County Museum of Art, Los Angeles, CA. (catalog); 1983, "A Heritage Renewed," University Art Museum, Santa Barbara, CA.; 1982, "The Michael and Dorothy Blankfort Collection," Los Angeles County Museum of Art, Los Angeles, CA. (catalog); 1982, "Exhibition of Contemporary Los Angeles Artists," Nagoya City Museum, Nagoya, Japan, (traveled to Municipal Art Gallery, Los Angeles, CA.). *Awards/Grants:* 1981, National Endowment for the Arts, Artists' Fellowship Grant; 1980, Los Angeles County Museum of Art, Young Talent Purchase Award.

EDWARD RUSCHA *Exhibitions, Solo:* 1987, Robert Miller Gallery, New York, NY.; 1986-87, Leo Castelli, New York, NY.; 1986, Texas Gallery, Houston, TX.; 1986, Westfalischer Kunstverein, Munster, West Germany; 1986, Galerie Susan Wyss, Zurich, Switzerland; 1985, James Corcoran Gallery, Los Angeles, CA.; 1985, Fisher Gallery, Univ. of Southern California, Los Angeles, CA.; 1985, Tanja Grunert, Koln, West Germany; 1985, Musee St. Pierre, Lyon, France; 1982, Museum of Modern Art, San Francisco, CA. (travelling). *Group:* 1987, "The Importance of Drawing," Fuller Goldeen Gallery, San Francisco, CA.; 1987, "The Great Drawing Show," Michael Kohn Gallery, Los Angeles, CA.; 1987, "Panorama and Prospects," Holly Solomon Gallery, New York, NY.; 1986, "What It Is," Tony Shafrazi Gallery, New York, NY., "Spectrum: In Other Words," Corcoran Gallery of Art, Washington, D.C. *Collections:* The Art Institute of Chicago, Chicago, IL.; Hirshhorn Museum, Washington, D.C.; Los Angeles County Museum of Art, Los Angeles, CA.; Museum of Modern Art, San Francisco, CA.; Stedelijk Museum, Amsterdam, Netherlands; Walker Art Center, Minneapolis, MN.; Whitney Museum of American Art, New York, NY.

BETYE SAAR *Exhibitions:* 1988, "Betye Saar: Review of Installations," California State Univ., Fullerton, CA.; 1987, "Sentimental Sojourn—Strangers and Souvenirs," Pennsylvania Academy of the Fine Arts, Philadelphia, PA.; 1984, "In Context—Museum of Contem-

porary Art, Los Angeles, CA.; 1981, 1976, Monique Knowlton Gallery, New York, NY.; 1981, 1979, 1977, Baum-Silverman Gallery, Los Angeles, CA.; 1975, Whitney Museum of American Art, New York, NY. *Awards/Grants:* 1984, National Endowment for the Arts; Public Art Commissions: Miami Beach, FL., Newark, NJ., Los Angeles, CA.

PETER SHELTON *Exhibitions, Solo:* 1987, "floatinghouse, DEADMAN," Wight Gallery, Univ. of California, Los Angeles, CA. (catalog); 1986, "Peter Shelton: Recent Sculptures," L.A. Louver, Venice, CA.; 1984, "pipegut, waterseat and STANDSTILL," Portland Center for the Visual Arts, Portland, OR.; 1982, "white, round, HEAD," Artists Space, New York, NY.; 1982, "trunknuts, WHITEHEAD, floater," Open Space Gallery, Victoria, B.C.; 1981, "NECKWALL, footscreen, sleeper," Malinda Wyatt Gallery, Los Angeles, CA.; 1980, "HEADROOM, footspace," Artpark, Lewiston, NY.; 1980, "BIRDHOUSE, holecan," Chapman College, Orange, CA. (in conjunction with L.A. Institute of Contemporary Art "Architectural Sculpture" exhibition.); 1979, "SWEATHOUSE and little principals," (111 elements), Wight Gallery, Univ. of California, Los Angeles, CA. (traveled to Santa Barbara Contemporary Arts Forum, Santa Barbara, CA.) *Group:* 1985, "Anniottanta," Museum of Modern Art, Bologna, Italy.

ALEXIS SMITH *Exhibitions, Solo:* 1987-88, "Same Old Paradise," installation at the Brooklyn Museum, Brooklyn, NY.; 1987, "Alexis Smith ¢ Joseph Cornell: Parallels," Aspen Art Center, Aspen, CO. (catalog); 1986, "Viewpoint: Alexis Smith," Walker Art Center, Minneapolis, MN. (catalog); 1986, "Currents: Alexis Smith," Institute of Contemporary Art, Boston, MA.; 1982-1985, Margo Leavin Gallery, Los Angeles, CA. *Group:* 1987, "Avant Garde in the Eighties," Los Angeles County Museum of Art (catalog); 1986-88, "Individuals: A Selected History of Contemporary Art 1945-1986," Museum of Contemporary Art, Los Angeles, CA. (catalog); 1975, "Whitney Biennial," Whitney Museum of American Art, New York, NY. *Awards/Grants:* 1976, Fellowship Grant, National Endowment for the Arts.

MASAMI TERAOKA *Exhibitions, Solo:* 1986, 1985, 1982, 1979, 1977, 1975, Space Gallery, Los Angeles, CA.; 1985, United States Cultural Center, Amerika Haus, Berlin, West Germany; 1983, The Oakland Museum, Oakland, CA.; 1981, "Masami Teraoka/The Takeover of East and West" (prints), Zolla/Lieberman Gallery, Chicago, IL.; 1979, Whitney Museum of American Art, New York, NY. *Group:* 1987, "Avant-Garde in the Eighties," Los Angeles County Museum of Art, Los Angeles, CA.; 1986, Willard Gallery, New York, NY.; 1986, The Biennale of Sydney, Sydney, Australia; 1986, "Tokyo: Form and Spirit," Walker Art Center, Minneapolis, MN. (travelling exhibition). *Awards/Grants:* 1980-81, National Endowment for the Arts, Artist's Fellowship.

JOYCE TREIMAN *Exhibitions, Solo:* 1988, "Friends and Strangers," traveling show to Portland Museum, Portland, OR. and Rochester Museum, Rochester, NY.; 1988, Schmidt Bingham Gallery, New York, NY.; 1984, 1982, 1978, 1973, 1972, 1964, 1962, 1958, Fairweather Hardin Gallery, Chicago, IL; 1983-1988, 1981, 1979, 1978, Tortue Gallery, Santa Monica, CA.; 1981, 1975, 1970, 1966, 1963, Forum Gallery, New York, NY.; 1979, Drawings, The Art Institute of Chicago, Chicago, IL. (also, Grunwald Center for the Graphic Arts, Univ. of California, Los Angeles, CA.); 1978, "Retrospective, 1947-1977," Municipal Art Gallery, Los Angeles, CA. *Collections:* Los Angeles County Museum of Art, Los Angeles, CA.; Metroplitan Museum of Art, New York, NY.; Museum of Modern Art, New York, NY.; National Gallery of Art, Washington, D.C.

JAMES TURRELL *Exhibitions, Solo:* 1987, Kunsthalle, Basel, Switzerland (catalog); 1985, Museum of Contemporary Art, Los Angeles, CA. (catalog); 1982, Israel Museum, Jerusalem, Israel (catalog); 1980, Whitney Museum of American Art, New York, NY. (catalog); 1976, Stedelijk Museum, Amsterdam, Holland (catalog); 1967, Pasadena Art Museum, Pasadena, CA. (catalog). *Group:* 1986, "Individuals: A Selected History of Contemporary Art, 1945-1986," Museum of Contemporary Art, Los Angeles, CA. (catalog); 1986, "The 100 Days of Contemporary Art, Montreal 86, Lumieres: Perception—Projection," Centre

International d'Art Contemporain de Montreal, Montreal, Canada (catalog); 1983, "ARS, 1983," Fine Arts Academy of Finland, Art Museum of the Ateneum, Helsinki, Finland; 1982, "The 74th American Exhibition," The Art Institute of Chicago, Chicago, IL. (catalog). *Collections:* Chicago Art Institute, Chicago, IL.; Guggenheim Museum, New York, NY.; Museum of Contemporary Art, Los Angeles, CA.; Whitney Museum of American Art, New York, NY. *Awards/Grants:* 1975, 1968, National Endowment for the Arts; 1974, Guggenheim Fellowship.

DE WAIN VALENTINE *Exhibitions, Solo:* 1985, Honolulu Academy of Arts and Contemporary Arts Center, Honolulu, HI.; 1982, Laumeier International Sculpture Park, St. Louis, MO.; 1979, Los Angeles County Museum of Art, Los Angeles, CA.; 1970, Pasadena Art Museum, Pasadena, CA. *Group:* 1986, "Artist's Dialogue: De Wain Valentine," by Jane Livingston in *Architectural Digest;* 1985, Sculptures, Cartier Foundation for Contemporary Art, Jouy-en-Josas (Paris) France; 1984, California Sculpture Show, Fisher Gallery, Univ. of Southern California, Los Angeles, CA. (travelled to England, France, Norway and West Germany.) *Awards/Grants:* Member, Board of Trustees, Museum of Contemporary Art, Los Angeles, CA.; 1981, National Endowment for the Arts Grant; 1980, Guggenheim Fellowship.

JEFFREY VALLANCE *Exhibitions, Solo:* 1986, "Jeffrey Vallance," Living Art Museum, Reykjavik, Iceland; 1984, 1981, Rosamund Felsen Gallery, Los Angeles, CA.; 1983, "Aitutaki, A Series of Pacific Images," Rosamund Felsen Gallery, Los Angeles, CA.; 1982, "Jeffrey Vallance, Social Historian," Art Museum, Univ. of California, Santa Barbara, CA.; 1980, "An American in Senegal," Daniel Sorano Hall of National Treasure, Dakar, Republic of Senegal; 1978, The U.S. Senate: A Survey on the Arts, Washington Project for the Arts, Washington, D.C. *Group:* 1986, "TV Generations," Los Angeles Contemporary Installations; 1985, "Off the Street," Cultural Affairs Dept., Los Angeles, CA. (catalog), The Old Print Shop; 1984, "American Sculpture," Margo Leavin Gallery, Los Angeles, CA.

RUTH WEISBERG *Exhibitions:* 1988, Survey Exhibition 1966-1988, Slusser Gallery, Univ. of Michigan, Ann Arbor, MI.; 1987, "The Scroll," Hebrew Union College, New York, NY.; 1987, Associated American Artists, New York, NY.; 1986, "A Circle of Life," Hewlett Gallery, Carnegie Mellon Univ., Pittsburgh, PA. (also, Fisher Gallery, Univ. of Southern California, Los Angeles, CA.); 1983, Jack Rutberg Fine Arts, Los Angeles, CA. *Collections:* The Art Institute of Chicago, Chicago, IL.; Bibliotheque Nationale de France, Paris, France; The National Gallery, Washington, D.C., etc.

Awards/Grants: 1987, The University of Michigan's Outstanding Achievement Award for Alumni; 1986, USC's Phi Kappa Phi Faculty Recognition Award; 1984, Third Annual Vesta Award in the Visual Arts. Currently Professor of Fine Arts, Univ. of Southern California, Los Angeles, CA.

JOHN WHITE *Exhibitions, Solo:* 1983, "Selected Works 1969-1983," Municipal Art Gallery, Los Angeles, CA.; 1983, 1981, 1978, Drawings and Paintings, Jan Baum Gallery, Los Angeles, CA.; 1981, Drawings and Paintings, Roy Boyd Gallery, Chicago, IL. *Group:* 1973, "Four L.A. Sculptors," Contemporary Museum of Art, Chicago, IL. (catalog). *Collections:* Los Angeles County Museum of Art, Los Angeles, CA.; Guggenheim Museum, New York, NY. *Awards/Grants:* 1983-84, 1978, 1975, National Endowment for the Arts Fellowship. *Performances:* 1986, Los Angeles Contemporary Exhibitions, Los Angeles, CA.; 1981, Guggenheim Museum, New York, NY.; 1980, Portland Center for the Visual Arts, Portland, OR.

MARY WORONOW *Exhibitions, Solo:* 1986-87, Abstraction Gallery, Los Angeles, CA.; 1986-87, Bond Gallery, New York, NY.; 1985, Attack Gallery, Los Angeles, CA.; 1984, Zero Club, Los Angeles, CA.; 1983-84, Swope Gallery, Los Angeles, CA. *Group:* 1987, Jeffrey Linden Gallery, Los Angeles, CA.; 1986, Sculpture show at El Bohio, New

York, NY. (catalog); 1985, Piezo Electric Gallery, New York, NY.; 1966-70, Worked with Andy Warhol on films: *Chelsea Girls, Milk, The Beard,* and *Hedy Lamarr.*

TOM WUDL *Exhibitions, Solo:* 1987, 1983, L.A. Louver, Venice, CA.; 1982, "Tom Wudl: Paintings 1975-1982," Arco Center for Visual Arts, Los Angeles, CA.; 1981, Ruth Schaffner Gallery, Santa Barbara, CA.; 1980, Aninaa Nosei Gallery, New York, NY.; 1979, College of Creative Studies Gallery, Univ. of California, Santa Barbara, CA.; 1971, Eugenia Butler Gallery, Los Angeles, CA. *Group:* 1987, "The Spiritual in Art: Abstract Painting 1890-1985," Los Angeles County Museum of Art, Los Angeles, CA.; 1984, 1981, 1976, L.A. Louver, Venice, CA.; 1978, 1974, 1972, Margo Leavin Gallery, Los Angeles, CA.; 1976, "Painting and Sculpture in California: The Modern Era," Museum of Modern Art, San Francisco, CA.; 1973, Paris Biennale, Paris, France; 1972, Documenta Number Five, Kassel, Germany.